IMAGES of America
THE LOWER BLACKSTONE RIVER VALLEY

Charles E. Savoie

Copyright © 1997 by Charles E. Savoie
ISBN 978-0-7385-6387-9

Published by Arcadia Publishing
Charleston SC, Chicago IL, Portsmouth NH, San Francisco CA

Printed in the United States of America

Library of Congress Catalog Card Number: 2008938762

For all general information contact Arcadia Publishing at:
Telephone 843-853-2070
Fax 843-853-0044
E-mail sales@arcadiapublishing.com
For customer service and orders:
Toll-Free 1-888-313-2665

Visit us on the Internet at www.arcadiapublishing.com

This work is dedicated to the past and present members of the Blackstone Valley Historical Society. Society members are dedicated to the preservation of artifacts and history related to the communities of Lincoln, Cumberland, Central Falls, Pawtucket, Woonsocket, and North Smithfield. Without the efforts of this group and other organizations like it, future generations might not realize what a truly remarkable and historically colorful area the Blackstone River Valley really is.

Contents

Acknowledgments		6
Introduction		7
1.	The Early Valley	9
2.	Agriculture	27
3.	Industry	41
4.	Religion	59
5.	Transportation	73
6.	Education	87
7.	Disasters	99
8.	Community	113

Acknowledgments

This work would never have been produced were it not for the contributions of photographs and other materials from many current and past residents of the Lower Blackstone River Valley. I would like to personally thank Mr. Roger Gladu, the late Dr. George Kokolski, Ruth Kokolski, Carmen Benoit, Everett and Esther Wilbur, Gordon and Barbara Jackson, Marie Gorman, R.K. "Ken" Smith, and Helen Smith, Henry and Rita Beaudoin, Marie Pelletier, Hope Tucker, the Town of Lincoln, Russel Archambeault, and Gregory Barbiaz.

I would also like to thank those individuals and families who have made contributions to the collections of the Blackstone Valley Historical Society. These people had the foresight to save relics, documents, and photographs which would have been lost to history had they not been set aside and preserved by thoughtful valley residents.

A portion of the royalties from this book will be donated to the Blackstone Valley Historical Society for library acquisitions and to the humane organization of Volunteer Services for Animals, Lincoln Chapter, to assist with their efforts on behalf of homeless animals.

<div style="text-align: right;">Charles E. Savoie</div>

Introduction

Although the communities of the Lower Blackstone River Valley comprise a relatively small area within the state of Rhode Island, they have a remarkably rich and colorful history. In the three and a half centuries since the Reverend William Blackstone settled the area of Cumberland known as Study Hill, the valley has been transformed from a primitive wilderness to an industrial center.

The friendly Wampanoag and Nipmuck natives of our valley welcomed the arrival of the first Europeans. Massasoit, the Wampanoag sachem (king), always maintained a warm relationship with the settlers, and vast tracts of native lands were sold to the newcomers over the years.

With Massasoit's death, and that of his son Wamsutta (who died suspiciously while in the custody of the English), relations between settlers and Native Americans began to turn sour. The old chief's second son, Metacomet, whose given English name was Philip, became the new King of the Wampanoags during these tense times.

Fueled by bitterness over his brother's death, the loss of Native American land, and endless waves of new settlers, Philip decided to organize an Indian rebellion. In the spring of 1675 the attacks began. In our own valley homes and buildings were burned, including the late William Blackstone's Study Hill home and library. Skirmishes took place in Limerock Village and outright massacres occurred near Dexter's Ledge in Central Falls, and at the nine men's misery site in Cumberland. In the end the rebellion was put down and Philip's efforts only further weakened the Native American presence in the Blackstone Valley.

After King Philip's death in August of 1676, more people ventured out of the larger towns to settle the "North Woods," and other areas of the valley. New homesteads, meetinghouses, taverns, and primitive mill sites were built using building materials produced by Lower Valley gristmills, forges, and lime kilns.

During the revolution a warning beacon was erected in case of English intrusion into Cumberland, and cannon were cast at the Wilkinson forge in Manville. In addition, arms were stockpiled in a number of Colonial homes in the valley. The fight for independence left our area untouched, however, and throughout this period the agricultural, commercial, and early industrial economy of the valley continued to expand.

In 1793 Samuel Slater touched off the American Industrial Revolution with the construction of Slater Mill in Pawtucket, and over the next few decades early wooden mills and their dams would give way to larger stone, and finally brick, industrial complexes. The Blackstone Canal, new roads, and the railroad continually improved the means of transporting raw and finished goods to and from Providence.

The incredible expansion of the textile industry during the mid- to late 1800s encouraged countless numbers of French-Canadian, Irish, Italian, and Polish workers (operatives) to seek employment in the Blackstone Valley. By the 1920s, things were very different. The Depression and the relocation of textile operations to the southern United States forced a hard economic adjustment onto the residents of the Lower Valley and other local industrial areas. Slowly mill operatives found new areas of employment, while future generations took advantage of new high-tech and service-related job opportunities. Today the people of the Lower Blackstone Valley are no longer dependent on the waterpower which once drove the local economy.

Over the years, curious and divergent interests among residents of the lower valley led to the establishment of the municipal boundaries we are familiar with today. The lack of a common purpose between voters living near the river's industrial centers and those in outlying agricultural areas caused the formation of some new towns. In other instances the cause was more political.

The town of Cumberland, for instance, was formed when portions of the Rehoboth North Purchase, acquired from the Indians in the 1600s, were annexed to Rhode Island from Massachusetts by royal decree in 1747. Also known as "the Gore," this territory had been in dispute between the colony of Rhode Island and Plymouth Colony for over a century. Included in the new town of Cumberland was "Woon Suckete," (Thunder Mists), the village at Woonsocket Falls. Over time, other districts developed their own unique village identities within the confines of the town of Cumberland. These included Valley Falls, Lonsdale-(East), Berkeley, (New) Ashton, and Cumberland Hill.

The town of Pawtucket (east side) was established in 1862 after having been severed from Seekonk, Massachusetts, and transferred to Rhode Island. In 1874 the older Western Pawtucket Village (which had been part of a greater town of North Providence) was unified with its eastern counterpart. This new enlarged town of Pawtucket formally became a city in 1885.

Woonsocket was set off from Cumberland and became a town in 1867. It received additional territory from the division of Greater Smithfield in 1871, and became a city in 1888. Woonsocket, like other towns in the valley, had its own village communities and districts, including Woonsocket Falls, Bernon, Globe, Social, Hamlet, and Jenckesville.

The dismemberment of Greater Smithfield also led to the creation of the town of Lincoln in 1871. Lincoln's village districts included Central Falls, Manville, Albion, Quinnville (Old Ashton), Limerock, Lonsdale (West), Saylesville, and Fairlawn. Central Falls was first Smithfield's, then Lincoln's most populous village. In 1895, the voters of Lincoln approved a controversial measure which set off Central Falls from the rest of the town. It became a city in its own right the very same year.

Changing municipal boundaries could never alter the common bond shared by the communities of the Blackstone Valley, however. The river flowed through all of the cities and towns and each shared in its productive and destructive capabilities.

One
The Early Valley

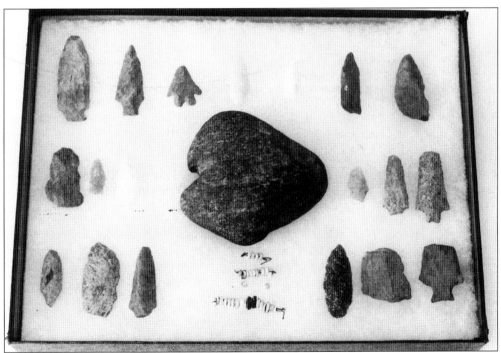

Arrowheads, tools, and shellbeads (wampum)—lasting reminders of the valley's first inhabitants. Wampanoag and Nipmuck Indians hunted, fished, and camped in the Lower Blackstone Valley. Tools and arrowheads were fashioned from rocks common in our area including quartz and granite. Shellbeads were used for decorative belts and as a form of money. They were ground from the thickest portions of hardshell clams and traded in sections called "fathoms." English settlers also used wampum as a medium of exchange. The English assigned a value of one penny per six beads of white wampum, and two pennies for the more desirable blue wampum. In Rhode Island the use of wampum as currency was discontinued in 1662. (Ken Smith-PVHS.)

Draught of the Plain Lots

The ninth day of the 4th month 1645 at a meeting of the townmen on public notice given the same day lots were drawn for the great plain as follows and to begin upon west side and the first upon the west shall be last upon the east

Lot	estate	Names	Acres	No.	estate	Names	Acres	
1	535	Stephen Pearce	21¼	33	50	Nichols Ide	2	
2	50	Wm. Walker	2	34	71	James Clark on John Bowen	2¼	2⅞
3	288½	Robert Martin	9¼	35	81	Edward Sale	3½	
4	306½	Edward Gilmore	12¼	26	50	George Kendrick	2	
5	50	James Redaway	2	37	100	Mr. Howard Sen.	4	
6	834	Richard Wight	33¼	38	270	Richard Bowen	10¾	14⅞
7	60½	Abraham Martin	2¾₁₀	39	50	Edward Patterson	2	
8	100	Teachers R.R.	4	40	300	John Read	12	
9	254	Wm. Carpenter	10¼	41	50	John Matthews	2	
10	156	Robert Titus	6¼	42	100	George Right Duggett	4	
11	419	Walter Palmer	16¼	43	100	Robert Sharp Leonard	4	⅞
12	50	John Fitch	2	44	127	Ephraim & Peter Hunt	17	⅒
13	200	Alexander Winchester	8	45	50	Zachariah Read	2	00
14	50	Samuel Butterworth	2	47	69½	John Millard	2¾	
15	53	William Sabin	2⅛	48	156½	Obadiah Holmes	6¼	
16	100	Thomas Hill	4	49	50	Schoolmasters	2	
17	252	Edward Smith	10⅙	50	535	Mr. Peck	21½	
18	148	Edward Bennet	3½	51	100	Richard Ingraham	4	
19	160	Thomas Clifton & Stephen	6⅜	52	50	Isaac Martin	2	
20	50	Wm. Palmer Duggett	2	53	156	John Allen	6¼	
21	600	Brown Bullock	24	54	468	William Smith	18¾	
22	450	Wm. Chesbrook	18	55	330	Mr. Bonman	13	
23	270	Ralf Allen Sabin	10¾	56	100	Pastors	4	
24	50	James Bowen Sabin	2	57	100	Robert Wheaton	4	
25	200	Governor	8	58	94½	Mr. Morris	4	
26	266	Henry Smith	10⅔					
27	150	John Batten & Robert Fuller	6					

True record of the draught of the plain lots, April 9, 1645. In 1645, settlers drew lots for land in the Great Plains of the "Rehoboth North Purchase" made from the Indians. This area, which included present-day Cumberland, otherwise known as "the gore," was in territorial dispute between the Rhode Island and Plymouth, Massachusetts, colonies until the 1740s.

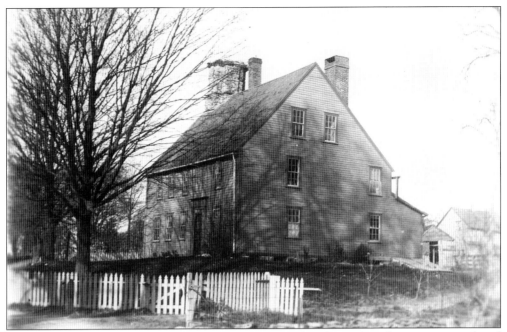

Eleazer Arnold House (built c. 1687), Great Road, Lincoln. This Colonial mansion was referred to as a "garrison house" due to the fact the spaces between the wood beamed walls were filled with tile and brick which, combined with its stone-end, made the house bullet-resistant. This precaution was deemed prudent after King Phillip's Indian attacks of 1675–76.

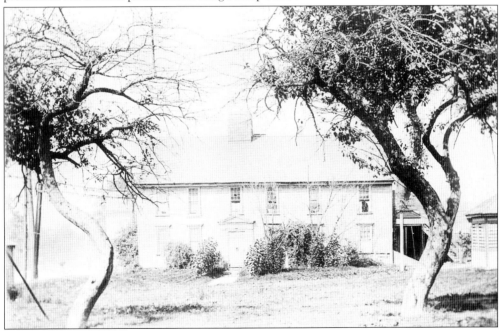

Jeremiah Sayles Tavern (built c. 1700), Pawtucket. This tavern is also known as the "Ox Tavern," "Lafayette House," and "Old Pidge House." Pawtucket Village (North Providence) town meetings were held in this building. A tollhouse and gate were also located on the same property.

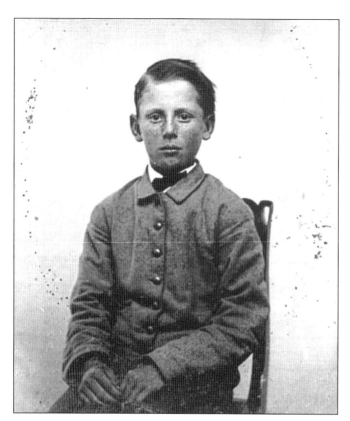

Late 1870s tintype of Frank Ditson. Mr. Ditson was a nineteenth-century valley resident and a direct descendant of the Indian warrior King Philip. After Philip's death, his wife and children were placed in indentured servitude under the English for about twenty years, and some of Philip's family eventually married local colonists.

An example of colonial scrip. Issued by order of the crown, these notes replaced the wampum and Spanish silver coins used by settlers of the valley during the early colonial period. Dated in the thirty-first year of the reign of King George II (1758), it carries a warning to early criminals that "to counterfeit is death."

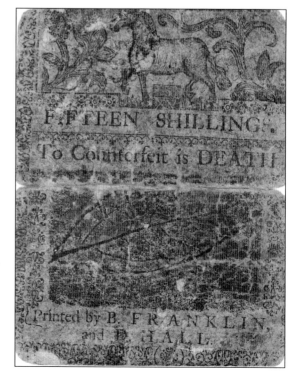

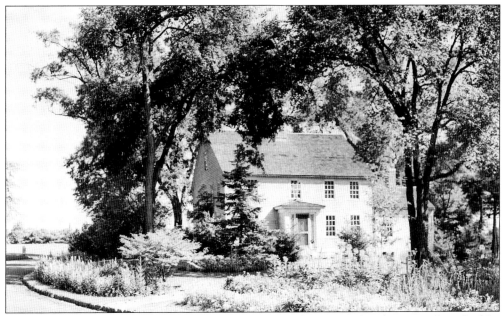

Daggett House (built c. 1685), Pawtucket. Built to replace an earlier homestead torched by King Philip's marauding warriors, the house is now a museum operated by the Daughters of the American Revolution, Pawtucket Chapter. Among the numerous artifacts on display is a china washbowl in which General George Washington washed his hands while on a comfort stop at the house.

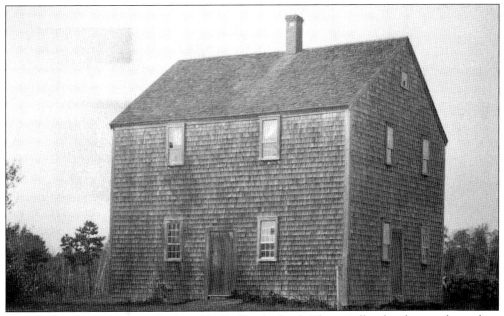

Elder Ballou Meetinghouse (built c. 1746), Cumberland. Three Ballou brothers and members of the Cook family settled near Iron Mountain in Cumberland in the early 1700s and built this wonderful two-story meeting house with a gallery and diamond-shaped leaded windows (which were eventually removed). It was the second-oldest meetinghouse in the state, but was lost to fire this century.

The gravestone of Joseph Jenks III. This gentleman truly helped shape the Lower Blackstone River Valley. In addition to being instrumental in construction of the bridge at Pawtucket, he was also involved in the family's gristmill operations and became the first colonial governor from the Blackstone Valley. He died in 1740.

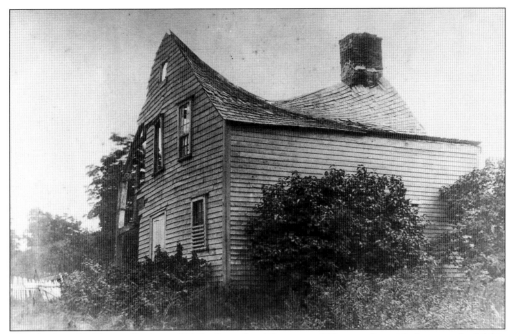

Joseph Arnold House (built c. 1716), Lincoln. The son of Eleazer Arnold chose to build his Colonial home in Quinsnicket (Native American for "place of large stones" or "stone houses"), which is now Lincoln Woods. Unfortunately, the house was severely damaged by fire at he turn of the century. This is how it appeared shortly before its demolition in 1910.

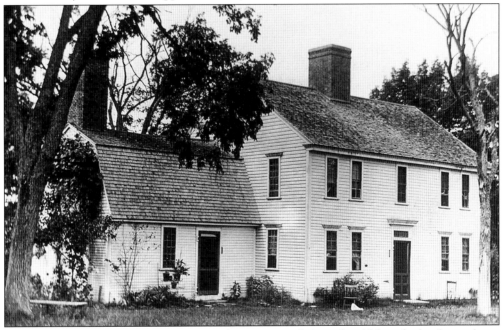

Israel Arnold/Olney House (built c. 1740), Great Road, Lincoln. Although this house bears the Arnold name, it was originally built by a member of the Olney family. The house is in a wonderful state of preservation due to the care of numerous owners over the years. It is truly one of Great Road's treasures of antiquity.

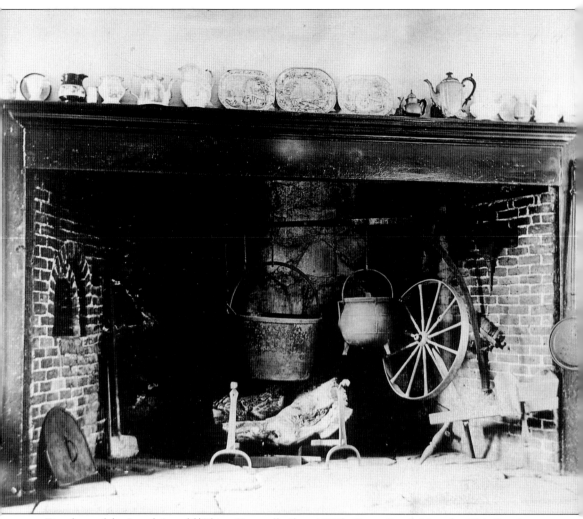

Fireplace of the Israel Arnold/Olney House (built *c.* 1740), Great Road, Lincoln. This fireplace is an excellent example of the oversized fireplaces found in many of the colonial homes of the valley. Constructed along with the rest of the house in the early eighteenth century, it is supposed to have accommodated logs so large and heavy that its early occupants had oxen drag them up to the house. Note the wonderful brick oven to the left.

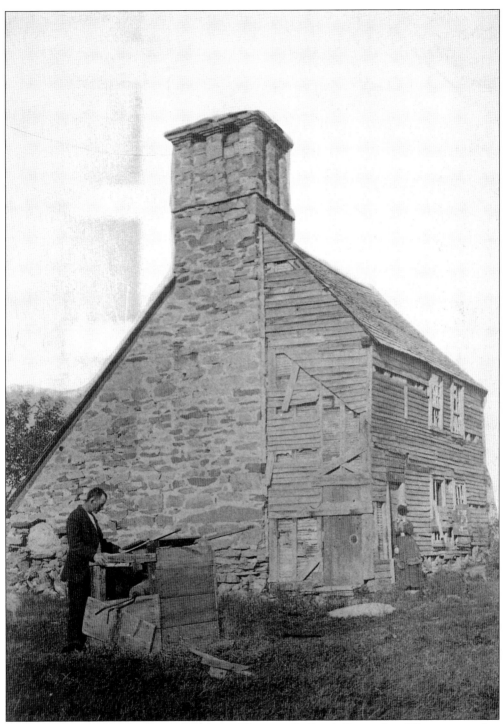

Samuel Smith House (built c. 1689), near Hammond's Pond, Pawtucket. This stone-ender, reminiscent of the Eleazer Arnold House in Lincoln, had an unusual history. Also known as "the Old Stone House," it served as the home of the former slave of a Mr. Kennedy who called himself "Prince Kennedy." Bullet casting also took place at this site.

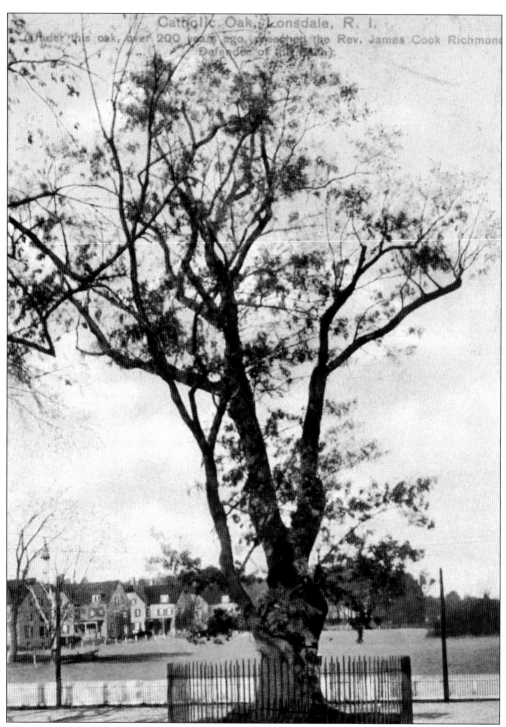

The "Catholic Oak." Taken down in April 1947, the Catholic Oak was the last living link between the first white settler of the Blackstone Valley, the Reverend William Blackstone, and the twentieth-century residents of his valley. Blackstone and other ministers such as the Rev. James Cook Richmond held open-air services under the branches of this ancient tree.

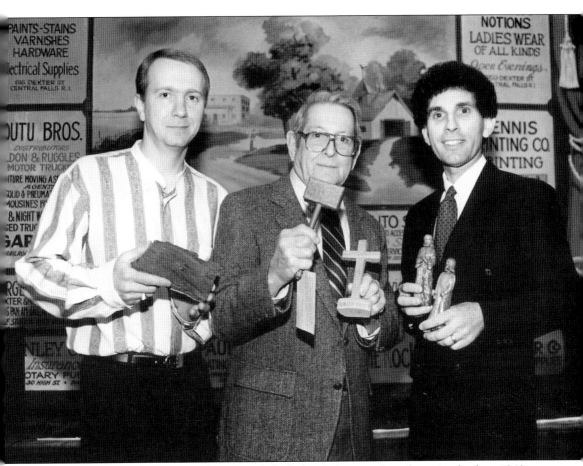

Catholic Oak artifacts. When the original Catholic Oak was taken down in the late 1940s, a few pieces were saved by Albert Bucklin. He carved some of the sections into religious folk art, and left one in its natural state. Shown holding surviving pieces of the historic oak tree are, from left to right: Charles E. Savoie (the author), Ken Smith (from the Blackstone Valley Historical Society), and Robert D. Billington (director of the Blackstone Valley Tourism Council). Thanks to the foresight of Mr. Bucklin, a few relics from William Blackstone's oak tree survive to this day. (Photograph by Susan E. Bouchard.)

Charles Keene Dam (built c. 1780), Central Falls. This is a 1936 photograph of the Colonial Dam, which was constructed for Mr. Keene to operate machinery for the production of edged farm tools. In time, a chocolate manufacturer named Wheat also produced chocolate at the site. The chocolate mill was so well-known that for a time what was to become the village of Central Falls was called "Chocolate Mills."

AN EPISTLE

TO THE

QUARTERLY and MONTHLY MEETINGS of Friends.

BELOVED FRIENDS,

FEELING at this time a renewed concern that the pure principle of Light and Life, and the righteous fruits thereof may spread and prevail amongst mankind, there is an engagement on my heart to labour with my brethren in religious profession, that none of us may be a stumbling block in the way of others; but may so walk that our conduct may reach the pure Witness in the hearts of such who are not in profession with us.

And, dear Friends, while we publicly own that the Holy Spirit is our leader, the profession is in itself weighty, and the weightiness thereof increaseth, in proportion as we are noted among the professors of Truth, and active in dealing with such who walk disorderly.

Many under our profession for want of due attention, and a perfect resignation, to this Divine Teacher, have in some things manifested a deviation from the purity of our religious principles, and these deviations having crept in amongst us by little and little, and increasing from less to greater, have been so far unnoticed, that some living in them, have been active in putting discipline in practice, with relation to others, whose conduct hath appeared more dishonourable in the world.

Now

Smithfield, Providence Monthly Meeting

A 1772 Society of Friends epistle. This epistle was read at the Quaker meetinghouse in Smithfield, now Lincoln. The Society of Friends was a religious sect opposed to armed hostilities of any kind. When the American Revolution approached, they lost many male members as patriotic feelings outweighed devotion to religious doctrine. This epistle warns of deviations from "Friends" teaching.

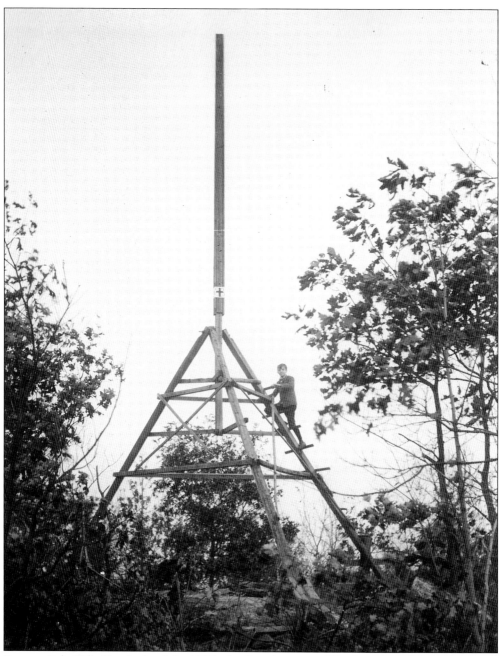

Beacon Pole Hill, Cumberland. In 1897, the Revolutionary War Beacon Pole was recreated. During the Revolution, a pot of pitch at the top of the pole was lit in times of crisis. From Beacon Pole Hill the fire could be seen from Boston and Providence. This pole was lost in a forest fire *c.* 1910. (Photograph by A.L. Sherman, 1907.)

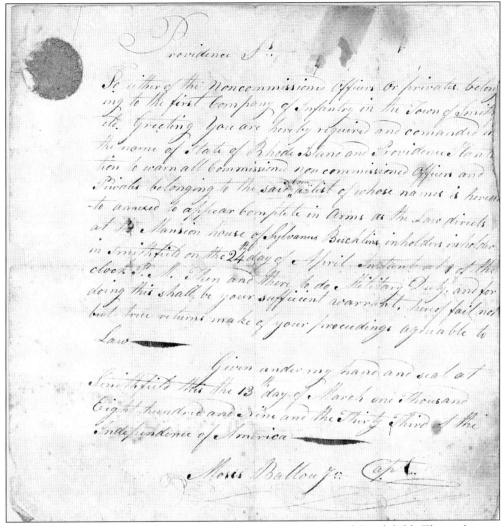

An 1809 muster order for the First Company Infantry, Town of Smithfield. This order was signed by Captain Moses Ballou. Stephen Arnold was paid $2.50 for notifying all members of the First Company to appear at the home of Sylvanus Bucklin for this muster, complete in arms.

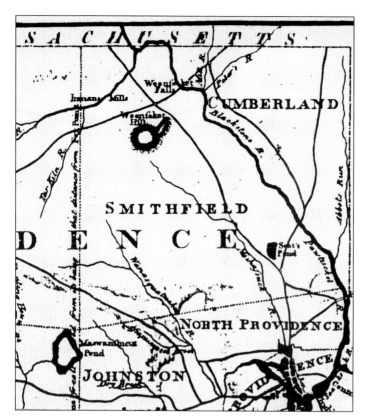

Map of the Lower Blackstone River Valley. This map dates from 1796, and on it one can see how many of today's communities had yet to arrive on the scene.

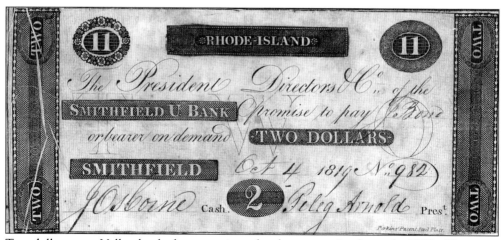

Two-dollar note. Valley banks began to issue local currency in the early 1800s. This note was issued by the Smithfield Union Bank. At that time, the town of Smithfield included the present-day valley communities of Lincoln, Central Falls, and a large part of Woonsocket. This specimen was hand-signed by well-known local merchant and bank president Peleg Arnold and bank cashier John Osborne.

Louisquisset Turnpike Company Toll Gate Keeper's House (c. 1807), Louisquisset Pike, Lincoln. The Turnpike Company was formed in 1806 to collect tolls to pay for the construction of the new turnpike from Smithfield to Providence. The South Gate tollhouse was probably on Charles Street in North Providence. Pikes were stretched across the road at both locations, and the turnpike enjoyed a good deal of commercial traffic, as the road facilitated the transportation of quicklime from Smithfield-Limerock to Providence. When the turnpike closed, the building was used as a hotel, farmhouse, and eventually was acquired by the Limerock Grange. In 1971 the building was named "Northgate" and became the headquarters of the Blackstone Valley Historical Society.

Ebenezer W. Peirce. Mr. Peirce was born in 1822, and was a direct descendent of Isaac Peirce, who fought King Philip's marauding Indians in the Lower Blackstone River Valley.

Captain William P. Perrin. The descendants of valley colonists heeded the union's call to arms during the great rebellion. Perrin was an officer of Battery B, Rhode Island First Light Artillery, during the Civil War. This brave valley soldier was wounded and captured, and he endured the hardships of a confederate prison. He suffered from poor health after the war and died in 1876.

Two

Agriculture

A c. 1890s photograph of cattle grazing the area between Sherman Avenue and Great Road in Lincoln. Before the advent of today's super-stores, most valley residents were self-sufficient in producing most of their food. Many had gardens (if not a small farm), and kept some poultry or livestock. Those who had large amounts of land and were capable of producing more food than they required used the early roads, such as Great Road, to ship their goods to markets in Providence and Pawtucket. (Photograph from Gordon Jackson.)

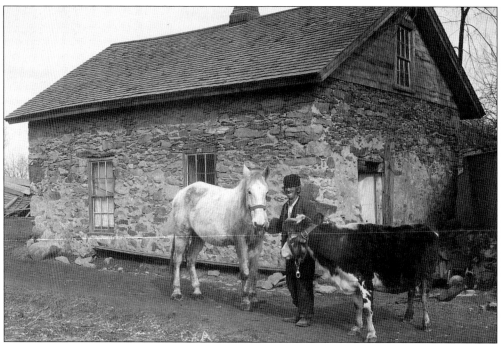

A 1926 photograph of "Jack the Bunker," a notable Pawtucket resident who lived at the corner of Broadway and Margaret Streets. Jack kept pretty much to himself and wore the same clothes just about every day. A likable chap in every other respect, he allowed this photograph to be taken of himself, his stone house, white horse, and cow. (Foster collection.)

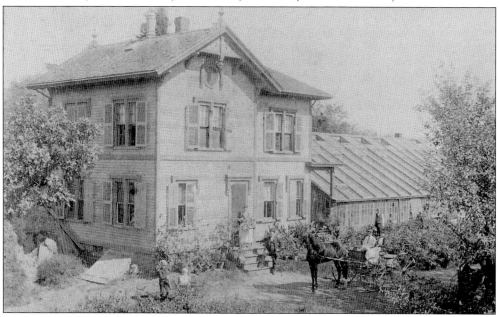

An 1872 photograph of Follett's mountain greenhouse, Central Falls. This home with greenhouse attached was located on the estate of Alvin A. Jenks, but was occupied and run by a gentleman named John F. Follett. In 1890, Alvin Jenks conveyed the land to the town of Lincoln and it eventually became the site of Jenks Park. (Foster collection.)

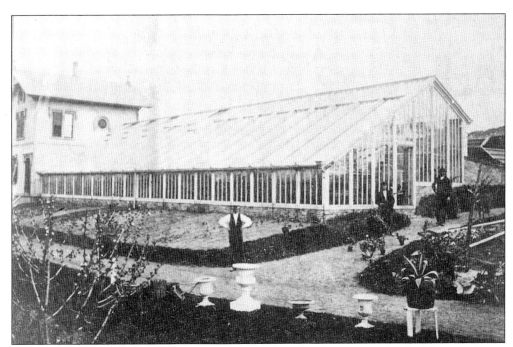

An 1872 photograph of Mr. Follett in front of his greenhouse in Central Falls. The greenhouse on the "mountain" was one of the earliest, if not the earliest greenhouse in the Lower Blackstone Valley. Mr. Follett provided young plants to farms and local gardeners alike, just as modern nurseries do today. (Foster collection.)

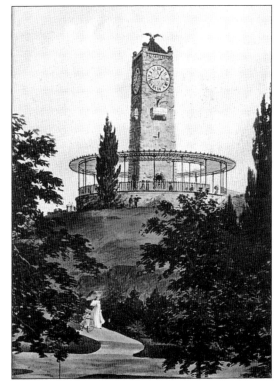

Caroline Coggswell Tower Memorial, Jenks Park, Central Falls. This turn-of-the-century postcard view of Jenks Park shows the "mountain" upon which Follett's greenhouse was located. After the land was transferred to the town, the house and greenhouse were torn down. The tower, with its clock and unusual umbrella, was erected c. 1900 to perpetuate the memory of Caroline Coggswell of Smithfield.

An 1885 photograph of the Arnold Homestead, Central Falls. This homestead was located on Clay Street. Though not a true farm, gardens and orchards were tended at the site. (Foster collection.)

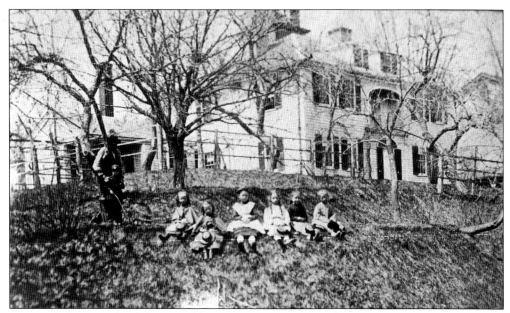

An 1813 auction notice, Pawtucket/Seekonk. This notice describes a public sale of a home and several fenced and cultivated acres along the Boston Road (now busy Route 1), on Pawtucket's east side. The annexation of this section of Pawtucket from Massachusetts to Rhode Island took place in 1862. (BVHS.)

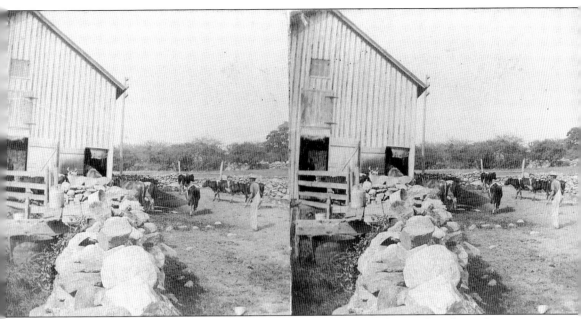

Ira Angell's barnyard, Great Road, Lincoln. Ira (locals pronounced it Iree) is shown here in 1896, tending his cows. He was involved in the lime industry, mail service, and was a charter member of the Limerock grange. His farmhouse was once one of the Mowry Taverns (the first of which was operated in the eighteenth century at the old Eleazer Whipple house, which is no longer standing). Ira kept an old home comfort stove in the center of his large kitchen ell. Visitors in wintertime often found him sitting before the open door of his stove, with his feet stuck well inside, boots and all. (Everett Wilbur.)

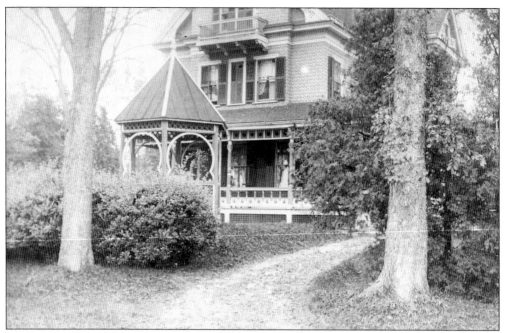

George F. Jenckes House, corner of Simon Sayles and Great Roads, Lincoln, c. 1890. Mr. Jenckes lived in Pawtucket, where he had a business, but he also operated a dairy and summered at this site in the town of Lincoln. (Mr. and Mrs. Everett Wilbur.)

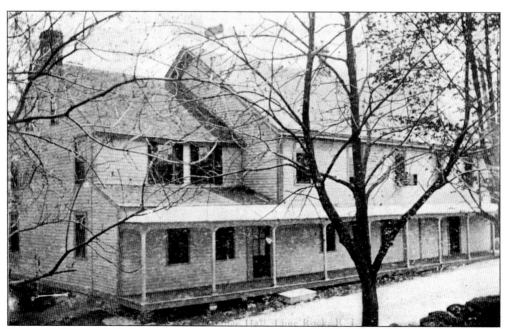

Limerock Grange Hall, Louisquisset Pike, Lincoln. This photograph postcard shows the Grange Hall as it appeared in 1910. The porch was later removed. The Grange originally met at Ira Angell's large home, but in 1904 the meetings became too loud for Ira and he threw them out because "they were making a hell of a lot of noise."

Rufus Jenckes (1827–1895), Lincoln. Descended from the Pawtucket Jenckes and the prominent Ballou family, Rufus was a well-to-do gentleman farmer who worked his family's homestead on the "rural highway" (now Jenckes Hill Road). Tragically, he lost his first wife and four of his seven children in the three years before his death. (Hope Tucker, BVHS.)

Adna Jenckes (1861–1892), Lincoln. Rufus' daughter was a well-educated young lady who became a prominent Lincoln poet. This original cabinet card photograph was reproduced and distributed to her fans. A good friend of Adna's was celebrity Ben Cotton, "The Minstrel Man." Adna and her three sisters died young, and in quick succession, possibly from consumption/tuberculosis. (Hope Tucker, BVHS.)

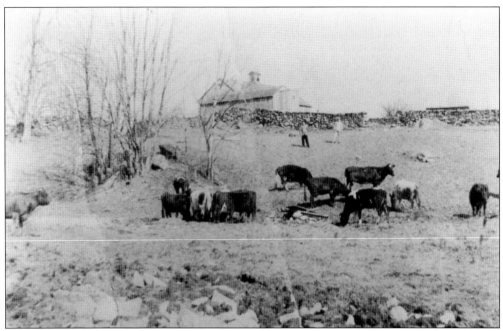
Mann Farm (built c. 1809), Albion Road, Lincoln. This is a frontal view of the Mann farmhouse and barns as they appeared at the turn of the century. (Roger Gladu.)

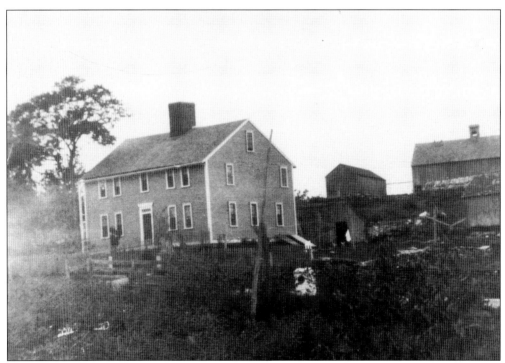
Mann Farm, Albion Road, Lincoln. This c. 1900 photograph shows the farmhands in the field behind the Mann farmhouse. With them is a herd of cattle which once roamed a more agricultural Albion. (Roger Gladu.)

Annual State Grange Field Day program, Lincoln, 1913. The Limerock Grange hosted the State Grange Field Day at Wilbur's Grove in Limerock on August 14, 1913. Although a farmers' association, the granges played a large social role as well. Events held included a pig race, three-legged race, and candle race. (Hope Tucker, BVHS.)

Degree of Flora presented to Limerock Grange member Martha Bastow by the State Grange on May 16, 1921. (BVHS.)

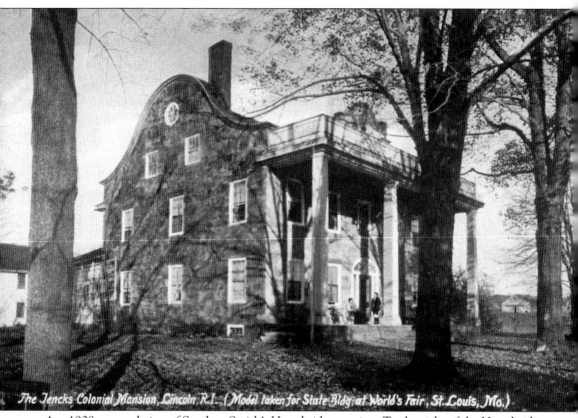

A c. 1908 postcard view of Stephen Smith's Hearthside mansion. To the right of the Hearthside mansion, between the two large trees, a barn is visible. This is the original barn of Chase Farm. The Chase family operated a large dairy farm from the 1890s until 1965. The barn pictured was struck by lightning and destroyed in the mid-1920s, an incident which claimed the lives of all of the farm's horses. Luckily, the cows who were grazing unprotected in the fields were unharmed.

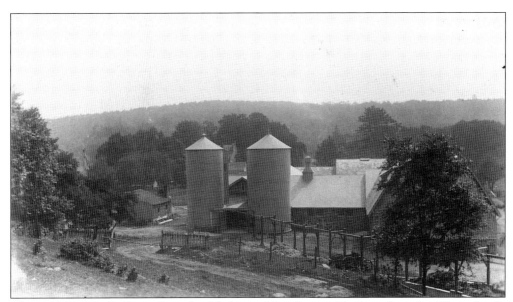

Chase and Butterfly Farm, Lincoln. Undaunted by the terrible barn fire, the Chase family acquired the Sayles' Butterfly Farm adjacent to their own property. and the dairy farm on Great Road became known as the "Chase and Butterfly Farm."

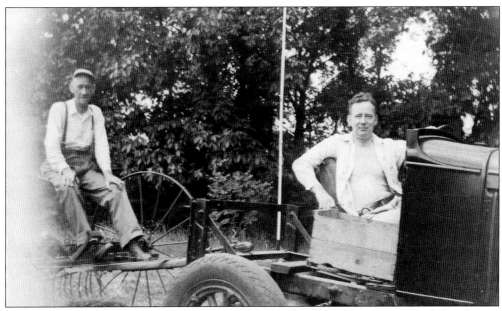

An early 1940s photograph of John H. Jackson (left), and Robert Lunny (right), taking a breather from some hay-raking on the Jackson property in Lincoln. (Gordon Jackson.)

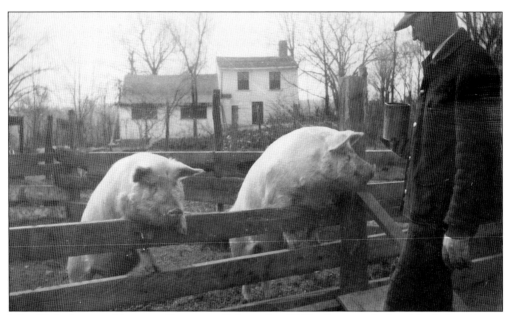

John H. Jackson and his pigs. You can tell from this 1940s photograph that Mr. Jackson's pigs were well treated and liked their owner. (Gordon Jackson.)

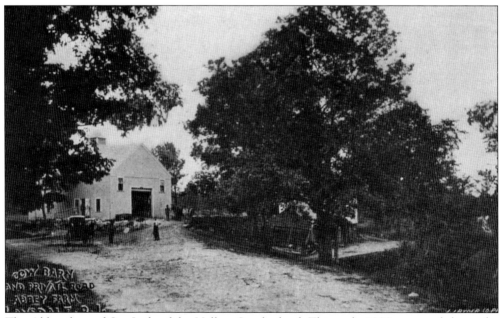

The Abbey farm of Our Lady of the Valley, Cumberland. This early-1900s postcard shows the cow barn of the Cistercian (Trappist) monastery located off of Diamond Hill Road.

A list of exhibits and vendors of the 1929 Woonsocket Poultry Association. The list attests to the agricultural interests of many Woonsocket residents well into the twentieth century. A viable organization for many years, the association held yearly exhibitions at various locations throughout the city.

Samuel Hill Farm House (built c. 1781), Old River Road, Lincoln. The "three holes in the chimney house" has the most unusual history of any valley homestead. Samuel's daughter Deborah inherited the house when he died and took in three motherless children under the guise of caring for them. She overworked and beat these children. One child, Anne, was locked behind iron doors in the ash pit of the home's large chimney, kept there for days on a diet of bread and water. She documented her ordeal in the nineteenth century book, *Three Holes in the Chimney*, which she authored under the pen name of "Didama." She altered some characters names by one letter, hence Deborah's last name was "Gill" in the book. (Town of Lincoln.)

Three

Industry

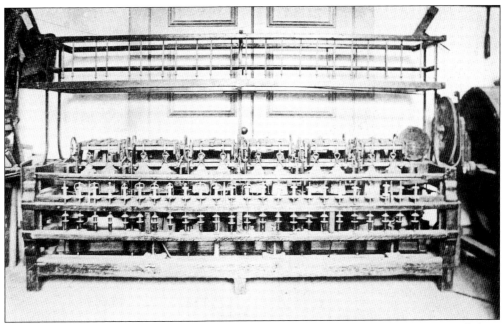

A 1936 photograph of an original spinning frame, which Samuel Slater re-created from memory. Slater ignited the American Industrial Revolution at Slater Mill, Pawtucket, in the early 1790s with the introduction of British technology to the Blackstone Valley. Slater's process, combined with an endless supply of Blackstone River water power, paved the way for unprecedented growth and development within the Blackstone Valley. In the next century, other early industrialists modified and improved cotton-spinning technology. Textile shortages associated with the War of 1812 only helped to quicken industrialization of the valley. The machine pictured above was considered such a significant artifact of this nation's history that it was placed in the Smithsonian Institution in Washington, D.C. (BVHS.)

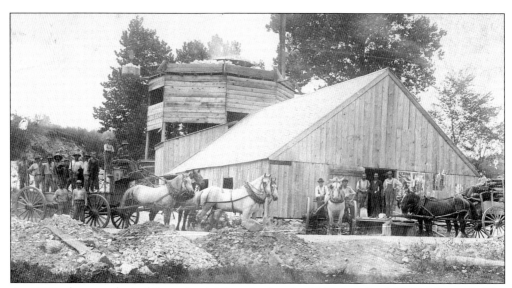

An 1890s photograph of a kiln and quicklime shed at the Old Jointa Rock Hold, Limerock. The wagons are situated on what is now Old Louisquisset Pike. Driving the four-horse team that hauled rock to the kiln is George Lambert. Standing on the team wagon are, from left to right: Israel Fountain, Ed Harris Jr., Albert Faucett, and Jake Schoder. (Everett Wilbur.)

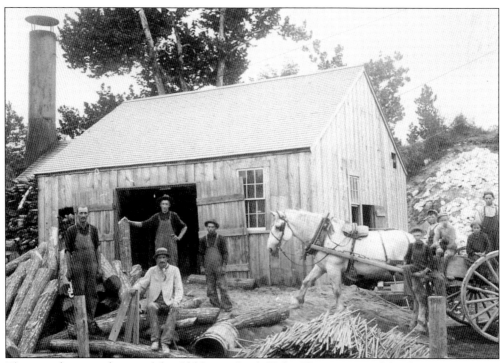

The pumphouse and crew of the Old Jointa Rock Hole. The crew posed for this picture in the late nineteenth century. By that time, the quarrying and burning of limestone was already a 240-year-old industry in Limerock. Initially begun as a part time occupation to supplement farming income, demand for the limestone eventually made its production an important local industry. (Everett Wilbur.)

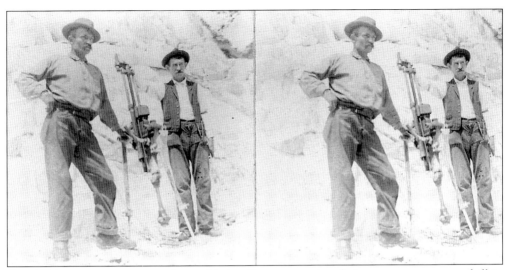
A c. 1896 stereoscopic image of two old-time limers manning their stone quarry steam drill in Limerock, Lincoln. (Everett Wilbur.)

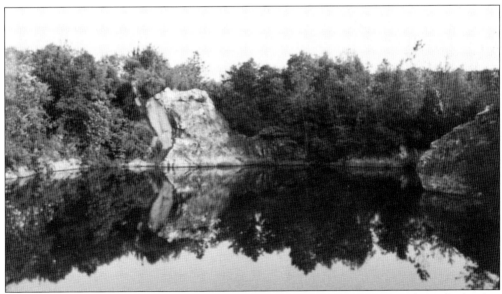
A limestone quarry. Serene waters now cover a quarry pit where the Harris and Wright families removed limestone side-by-side. Quarreling between the two grew so bitter that a "feuding wall" was constructed down the middle of the pit as the two operations quarried to incredible depths. The top of the wall is still visible today, just beneath the water line.

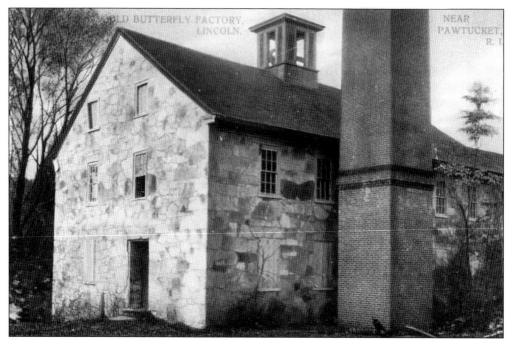

Butterfly Mill, Great Road, Lincoln. This is a postcard view of the original appearance of this early stone mill, built c. 1812 by Stephen H. Smith. Butterfly wing-shaped rocks can be seen to the left of the smokestack. The mill is an example of early efforts to construct more durable stone mills in the valley.

Butterfly Mill, Great Road, Lincoln (modern appearance). Storm damage forced a reconstruction of the mill during the twentieth century. The building's height has been reduced, and the structure is now a private residence. The butterfly wing-shaped stones are a prominent feature of the home's rebuilt chimney.

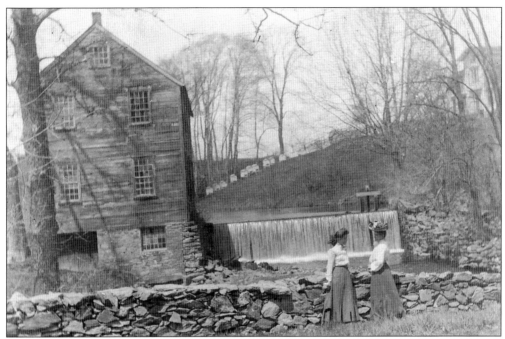

Moffitt Mill (built c. 1812), Great Road, Lincoln. This early machine shop is attributed to George Olney. In 1850, the mill and surrounding area were purchased by Arnold Moffitt. Moffitt upgraded the site, and during its long history it has been used for a dyeing shop, shoe lace factory, wheelwright operation, and blacksmith shop. The mill is currently in need of restoration.

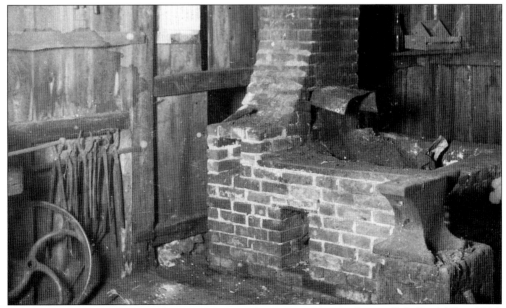

William Hanaway's blacksmithing operation. The operation started out of Moffitt Mill c. 1886. Hanaway later moved his equipment to a site across the street. When the blacksmith shop was restored a few years ago, the blacksmith shop building itself was moved across the street to its present location at Chase Farm Park. Blacksmithing demonstrations are held there periodically.

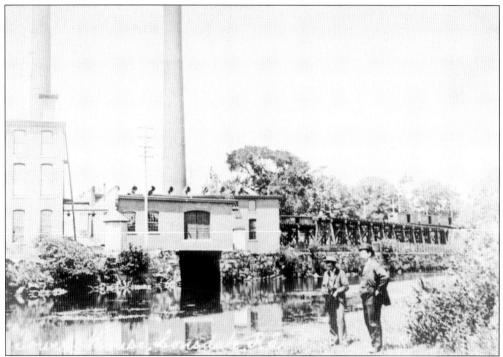

Lonsdale Mills boiler house and rail trestle, Lincoln. This c. 1900 photograph postcard shows the rail car trestle used to bring coal to the boiler room. The boilers consumed 3,000 pounds of coal a day.

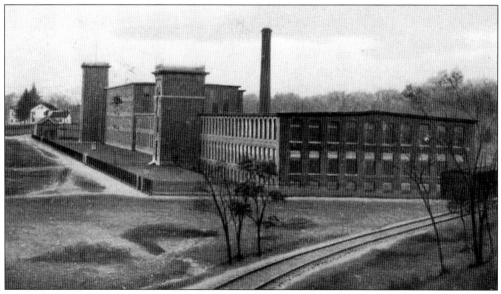

Lonsdale Mills, Lincoln, 1908 printed postcard. The Lonsdale Company had a number of mill complexes on both sides of the Blackstone River. Construction of the first Lonsdale Mill was commenced in 1832, with bleacheries added in the 1840s. The Lonsdale Company also built mill housing, sponsored church and school construction, and even provided buildings for the post office and stores.

A 1930s photograph of Mr. Anthony Burns. Mr. Burns was a bleachery operative at the Lonsdale Company. A Lincoln resident for many years, he eventually settled with his family on the east side of the river in Valley Falls, Cumberland. (Marie T. Gorman.)

A 1930s photograph of Miltie (Kiley) Burns, wife of Anthony Burns. Mrs. Burns worked as an operator for the growing New England Telephone and Telegraph Company. Her son, John K. Burns, became the chief of the Valley Falls Fire Department. (Marie T. Gorman.)

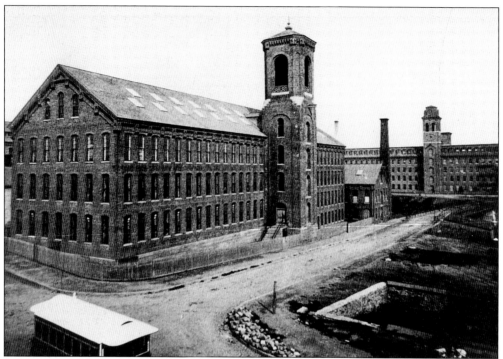

An 1880 photograph of Pawtucket Hair Cloth Mill, Cross Street Bridge, Central Falls. The Greene and Daniels Manufacturing Company can be seen in the background. The transfer horse-car in the foreground was operated by Mr. Cyrus Aldrich. (Foster collection.)

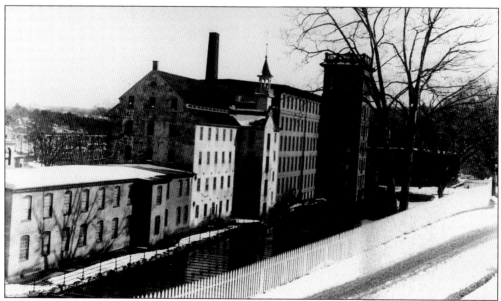

Albion Cotton Mill, Lincoln. This is a photograph of the Chase family's Valley Falls Company at Albion. The view shows the piecemeal approach to mill construction associated with an ever-expanding textile industry. The center section, which is the oldest, dates from the late 1850s. A brick addition was added on the south side in 1874, and the north side in 1909. (BVHS.)

Charles H. Merriman (1833–1920). Mr. Merriman and Henry J. Lippitt were co-founders of the Manville Company. They purchased the Unity Cotton Factory and renamed it in 1863.

Henry J. Lippitt (1818–1891). Mr. Lippitt, who was governor of Rhode Island from 1875 to 1877, and his partner expanded the Manville company by acquiring new manufacturing complexes in Woonsocket and Providence.

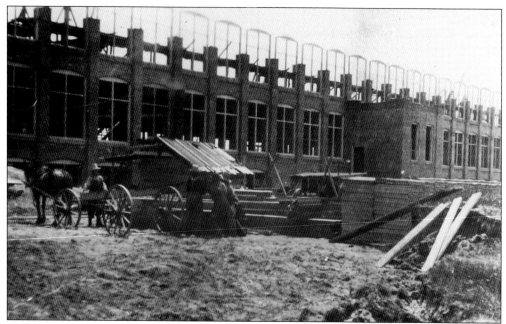

An 1872 photograph of the construction of Manville Company's mill number three. The mill was then the largest cotton mill in the United States. Prior to 1863, the existing mill complex at Manville was owned by the Chase family's Valley Falls Company. (Roger Gladu.)

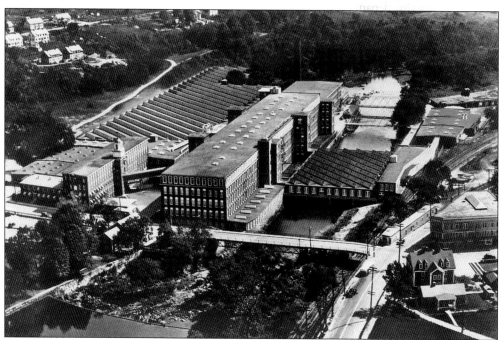

A 1939 aerial photograph of the massive Manville Jenckes Mill Complex. By 1923, the Manville Company had merged with the Jenckes Spinning Company. The mill employed roughly five thousand operatives to run a staggering 8,336 looms and over 290,000 spindles. The center span was built over the river and resembled a huge covered bridge. (Mr. and Mrs. Henry Beaudoin.)

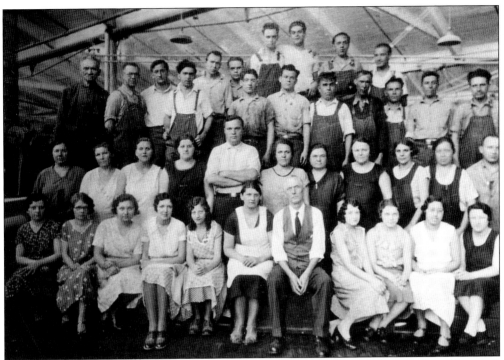

A c. 1938 photograph of Thomas Taylor (first row, centered between the ladies) and his work force in the weaving department of the Manville Jenckses Corporation.

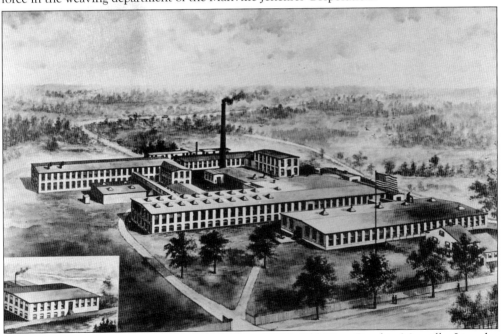

Contrexeville Manufacturing Company (built c. 1821), Old River Road in Manville, Lincoln. This plant was owned and operated by Russel Handy and his sons. The mill ran night and day, turning out jute and flax plush. The Handys owned the patents for both products and were the only producers of the items in the United States. (Roger Gladu.)

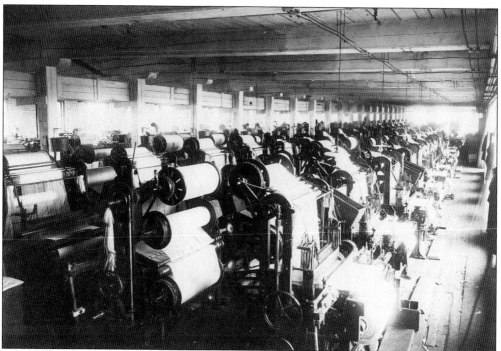

A c. 1930 photograph of the cotton cloth spinning room of the Manville Jenckes Corporation (Caren Benoit.)

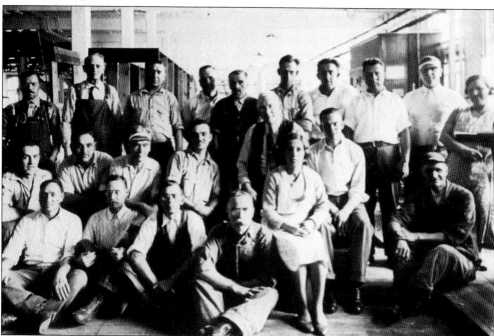

A 1942 photograph of Thomas Eddy (first row center) and his crew of workers in the shear room of the Manville Jenckes Corporation. In the middle row, second from the left, is Tom Benoit, who would soon open Tom's News, which was Manville's newspaper distribution center, and a gathering place for young and old alike. (Carmen Benoit.)

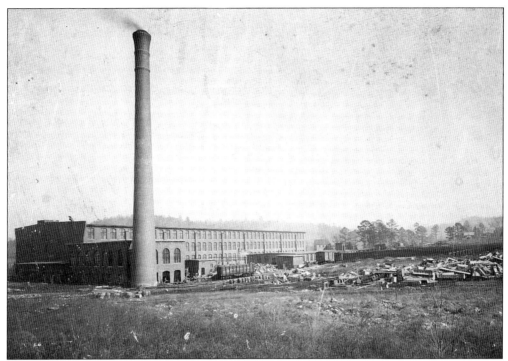

An 1872 photograph of the newly completed Berkeley Textile Mill in Cumberland. As you can see from the rubble and discarded scaffolding to the right of the picture, the mill was put into operation only days after completion. (Gordon Jackson.)

Thomas Y. and Stonewall "Stoney" Jackson. Among those who constructed the Berkeley Mill and its huge chimney in 1872 were these master stone masons. Thomas Y. Jackson is seated, and Stonewall "Stoney" Jackson is on the right. This photograph was taken in 1938, sixty-six years after they completed the Cumberland mill. The Jacksons worked on many such mill and stone-laying projects in the valley. (Gordon Jackson.)

William F. Sayles. Mr. Sayles founded the family textile operation in the southern part of the town of Lincoln in 1847. He chose to build upon a stretch of land considered of little industrial value in 1847. Mr. Sayles proved other speculators wrong in their assessment of the site, however. In time, his finishing operations were among the largest in the country.

Frederick Clark Sayles, the first mayor of Pawtucket and brother of William F. Sayles. Frederick entered into the operations at the Saylesville site in 1864 and together they formed the W.F. & F.C. Sayles Company. The brother's finishing plant and bleachery contributed significantly to the advancement of the textile industry of the Lower Blackstone Valley.

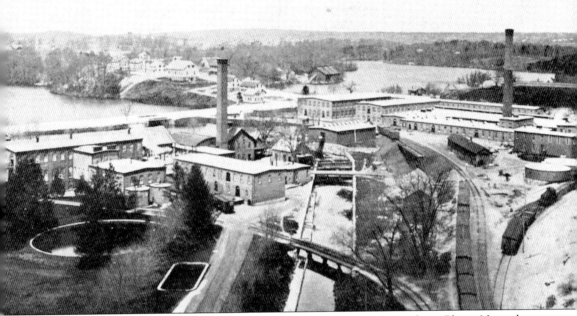

A c. 1910 photograph postcard of the Saylesville Bleachery and Finishing Plant. Note the railroad spurs which connected the complex to the Providence and Worcester Railroad Line. The mill village of Saylesville which grew up around the bleachery complex is the youngest of Lincoln's factory villages. Mill housing for the workers of the bleachery took on a more individual appearance, with few of the houses resembling each other. The Sayles brothers, like other mill owners, took an interest in the community they created. They built the Memorial Congregational Church in 1873, created a community hall, and made many other long-lasting contributions to this area of Lincoln. All of this was made possible because of the success of the mill complex pictured above.

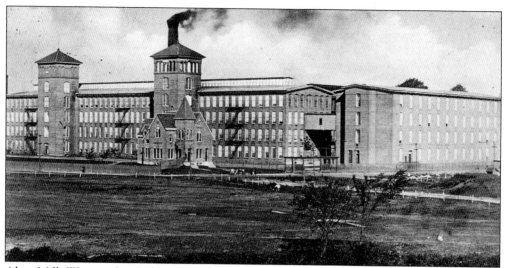

Alice Mill, Woonsocket Rubber Company, Buffam's Island, Woonsocket. Not to be outdone, the city of Woonsocket boasted some of the largest mills in the state of Rhode Island. Among the most impressive was the Alice Mill, constructed in 1889. In its heyday it was the largest rubber shoe and boot manufacturer in the United States.

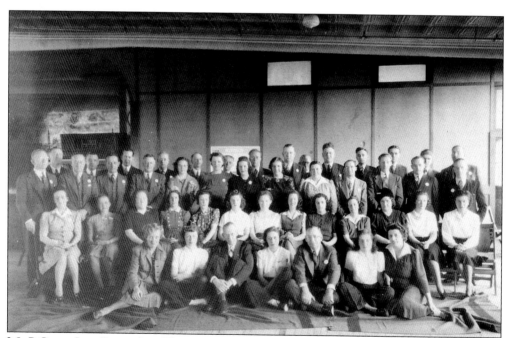

J & P Coats, Inc., Pawtucket. This is a 1942 photograph of the volunteer first aid group formed to treat injuries at the Pawtucket plant. Better training and safer equipment decreased the number of industrial accidents in the twentieth century.

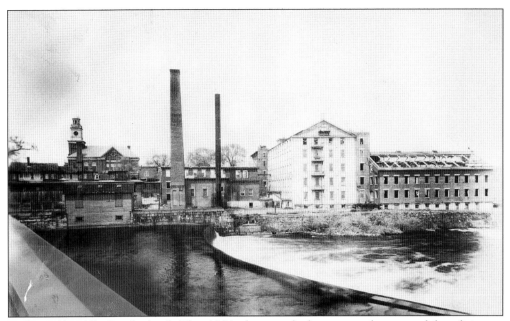

Valley Falls Mill, Cumberland. This 1934 photograph documents the start of demolition at the mill site. The decline of the Blackstone Valley textile industry began with the Depression, which ended well over a century of industrial expansion. In some areas the land a mill sat on was more valuable than an empty building and so the mills were razed.

A 1997 photograph of the Albion Mill (now Highland Falls condominiums). In many cases defunct valley mill sites were recycled, preserving historic structures while putting them to new use. The conversion of the Albion mill into a condominium complex in the late twentieth century is a prime example of the creative re-use of an old textile mill.

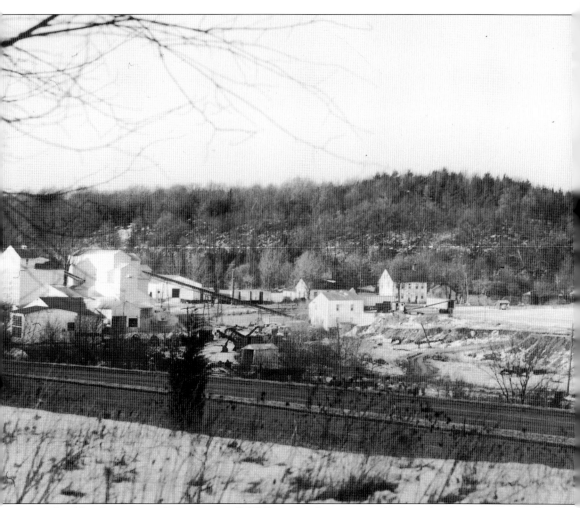

Conklin Limestone Operations, off Wilbur Road in Limerock, Lincoln. Some non-textile industries found new uses for their products in the twentieth century. Although limestone is no longer cooked to produce quicklime for mortar, it is still widely used in powdered form as a soil de-acidifier. It is also processed into chips and used as a decorative mulch, which can be seen in landscaped yards throughout the valley.

Four

Religion

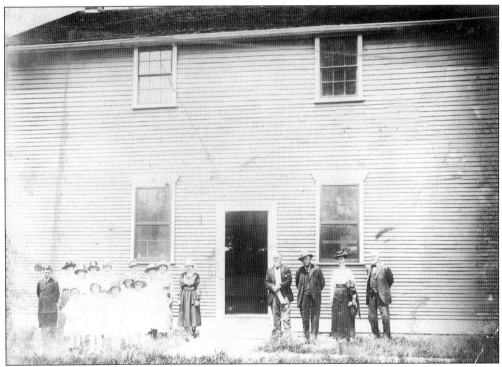

Friends meetinghouse, Great Road Historic District (Saylesville), Lincoln. All the posts and beams of this structure were pre-cut and marked for assembly in one day at a "meetinghouse raising" in 1703. The land, part of Smithfield at that time, was donated by Eleazer Arnold. Construction was a community affair, with all of the men putting their hearts into the work, while the ladies toiled preparing large outdoor meals to feed them. The building has the distinction of being the oldest Quaker meetinghouse in continuous use in Rhode Island and perhaps in all of New England. In this c. 1909 photograph, Elder Thomas Y. Jackson is pictured just to the right of the doorway. (Gordon Jackson.)

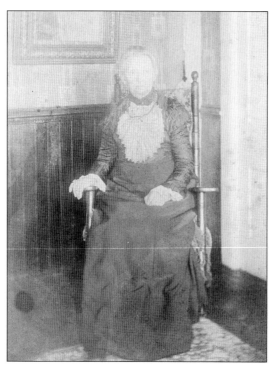

Alice (Oddie) Jackson, distinguished Quaker lady and wife of Elder Thomas Y. Jackson. In this early 1900s photograph, she is seen wearing the simple yet dignified clothing traditionally worn by Quaker women. (Gordon Jackson.)

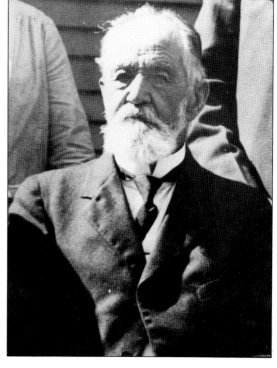

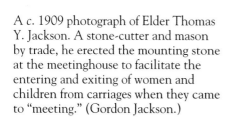

A c. 1909 photograph of Elder Thomas Y. Jackson. A stone-cutter and mason by trade, he erected the mounting stone at the meetinghouse to facilitate the entering and exiting of women and children from carriages when they came to "meeting." (Gordon Jackson.)

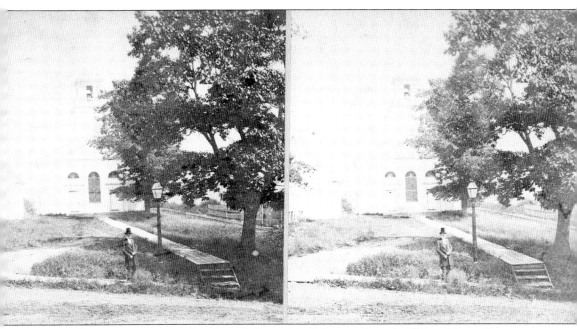

Nineteenth-century stereoscopic view of the original Limerock and Albion House Baptist Church. The church was built in 1836 on Meetinghouse Road in Lincoln. This is perhaps the only image of this structure in existence. This original church fell into disuse, as its remote location affected attendance. Abandoned, it was eventually moved to a new location and used as a barn until it was struck by lightning and burned c. 1855. (Mr. and Mrs. Everett Wilbur.)

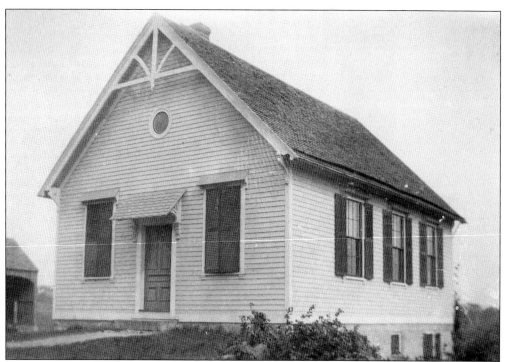

Turn-of-the-century photograph of the second of Limerock's Baptist churches, Wilbur Road, Lincoln. Before this wooden church was built in 1886, the Baptists of Limerock held their services in Ira Angell's Mowry Tavern. This smaller church more closely met the needs of local Baptists in the late nineteenth and early twentieth centuries. (Mr. and Mrs. Everett Wilbur.)

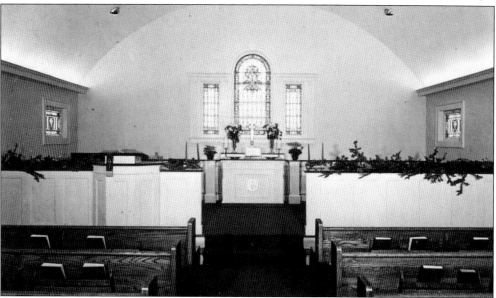

Interior view of the Limerock Baptist Church, on Wilbur Road in Limerock. The beautiful stained-glass windows in this church came from a building which was torn down in Providence. They were incorporated into this country church, which was in use until the new church was constructed on Great Road in 1975. (Esther Wilbur.)

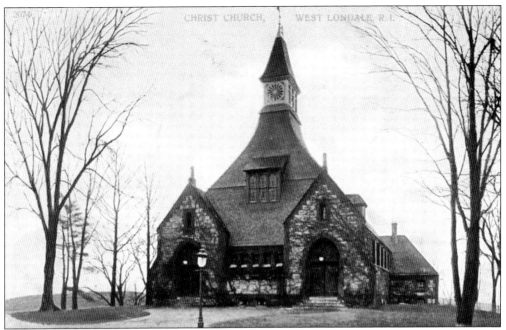

A 1908 postcard view of the rebuilt Christ Church Episcopal in Lonsdale, Lincoln. Organized with the help of the Lonsdale Company in 1834, the original Christ Church burned in the mid-1800s. The church pictured here faces Lonsdale Avenue and was built in 1880 on the same site as the original.

Reverend Albert Hilliker, rector at the new Christ Church Episcopal in the early 1900s.

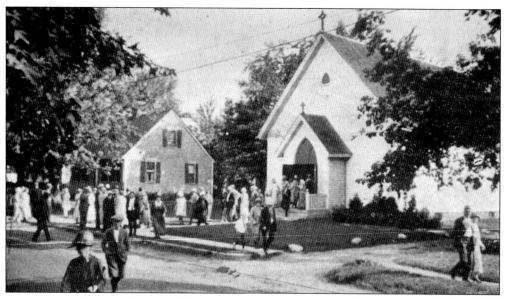

St. Ambrose Roman Catholic Church on School Street in Albion, Lincoln. This 1929 photograph-card produced for the church calendar shows parishioners leaving a Sunday morning service. Roman Catholic churches sprung up all over the valley in the late 1800s to service the religious needs of the tens of thousands of French-Canadian and Irish-Catholic mill operatives.

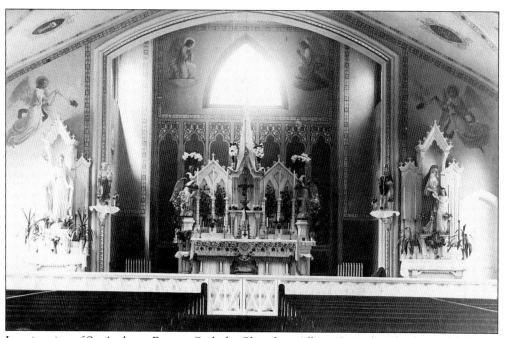

Interior view of St. Ambrose Roman Catholic Church in Albion, Lincoln. This beautiful church was constructed in 1893, with finishing touches taking an additional two years to complete. The result of the effort can be seen in this 1930s photograph.

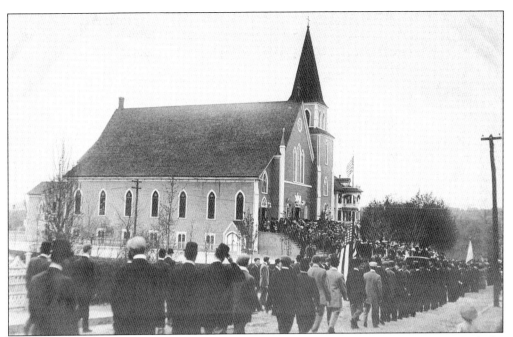

A 1910 photograph postcard of the original St. James/Eglise St. Jacques Roman Catholic Church on Division Street in Manville, Lincoln. The procession of villagers was part of the annual Fete De Corpus Christi celebration. The large wooden church pictured was constructed in the winter of 1873, but burned to the ground on November 10, 1919.

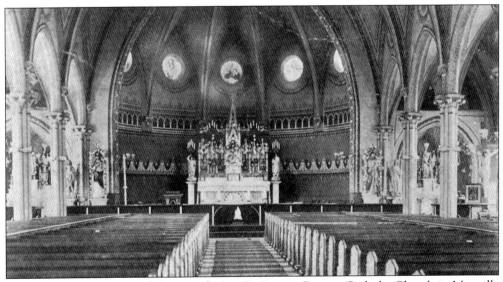

Interior view of the original St. James/Eglise St. Jacques Roman Catholic Church in Manville as it appeared before the 1919 fire.

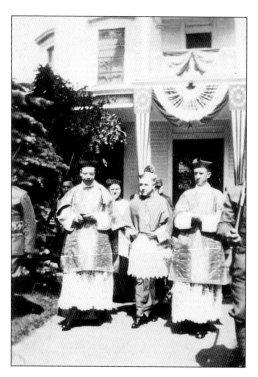

From left to right are Fr. Peloquin, Bishop Keogh, and Fr. Chauvin. In 1933 a procession left the St. James Rectory for a benediction of the foundation of the new church. The rectory itself dates from 1888. Though close to the church, it was not lost in the fire and is still the residence of the current parish priest.

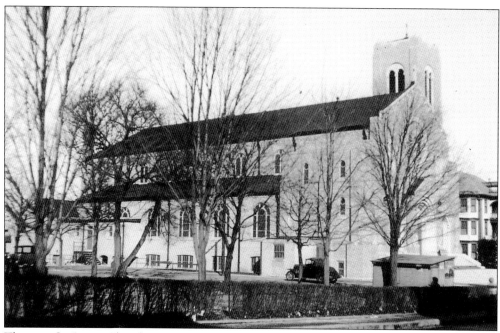

The new St. James Church on Division Street in Manville, Lincoln. By the mid-1930s a new brick and stone church had risen from the ashes to service the predominately French-Canadian parish. The materials chosen for construction were meant to make the church more fire-resistant.

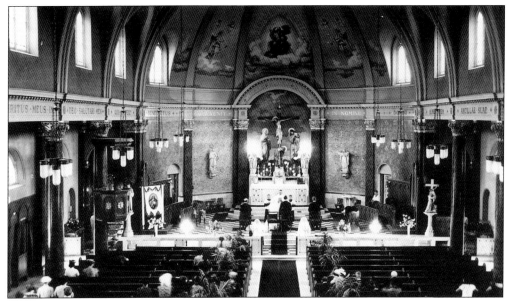
A 1940s photograph of the Romanesque interior of St. James Church in Manville. Although it has undergone some renovations, it appears much the same today.

A 1907 postcard of the Emmanuel Episcopal Church on Church Lane in Manville, Lincoln. This Greek Revival church was incorporated in 1836 and built by the Jenkins and Man Mill. The church eventually relocated out of Manville following a decline in the English population of the village. The inscription on the card is in reference to the very popular Manville Brass Band.

Our Lady of Fatima Retreat House, Manville Hill Road, Cumberland. Located just across the river from Manville, this former Victorian mansion inhabited by the Manville Company's overseer was purchased by the oblate fathers when the mill was selling off property. Converted into a retreat house, it was later abandoned, suffered fire damage, and was razed in the 1990s.

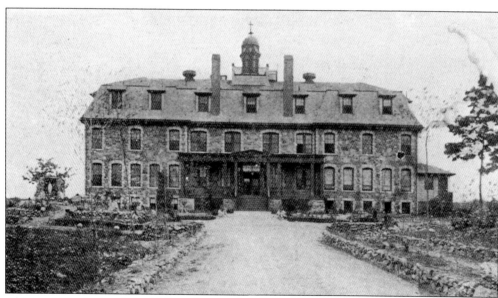

Abbey of Our Lady of the Valley, Diamond Hill Road, Cumberland. Originally part of the Amace Whipple Farm, the abbey site was acquired by Brother John Mary Murphy in 1900. Brother Murphy's Canadian monks cleared the land and used the native stones to construct this beautiful monastery and farm. The Town of Cumberland obtained this site for open space preservation.

Interior photograph of the Abbey of Our Lady of the Valley, Cumberland. A photographer managed to take this snapshot of an unidentified monk penning a letter or instructions at one of the monastery's large writing tables.

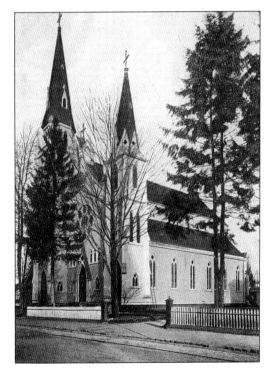

St. Joseph's Roman Catholic Church on Mendon Road in Ashton, Cumberland. This church cost only $8,000 to build in the 1870s, but is a fine example of a wooden Catholic church. The parishioners are very proud of their church and maintain it in a fine state of preservation.

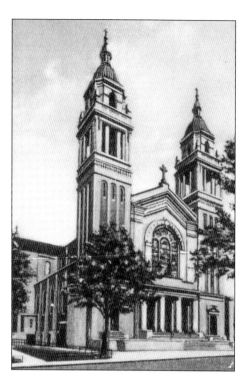

Exterior view of St. Anne's Church on Cumberland Street in Woonsocket. The members of this parish lavished $150,000 in 1918 to produce this huge brick and granite house of worship. The twin towers are truly impressive and can be seen from quite a distance.

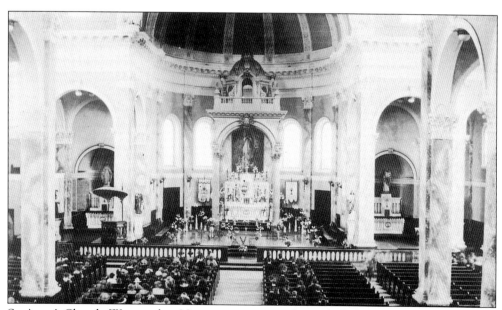

St. Anne's Church, Woonsocket. No expense was spared to embellish the interior of the church. It is a masterpiece of decorative plaster work, fine marbles, and ceiling paintings.

The Reverend Constantine Blodgett, second pastor of the Pawtucket Congregational Church. He served in that capacity and tended to his flock from 1836 to 1871.

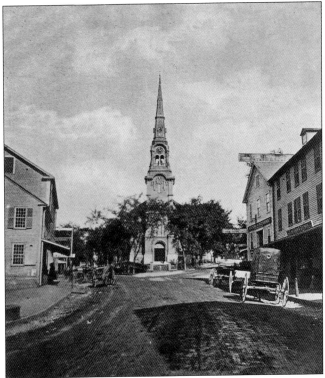

Pawtucket Congregational Church. Originally organized to accommodate nine valley residents who had quit the Congregational church in Attleboro, the new Pawtucket Congregational Church built their first house of worship in 1829. Like many early valley churches, it burned in 1864, perhaps due to a mishap involving candles. The structure pictured above is the successor to the original church. It was erected in 1868.

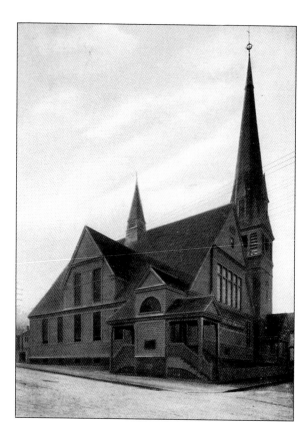

First Congregational Church, Cross and Evaleen Streets, Central Falls. Constructed in 1873 and a registered historic landmark, this former church is now the parish center of St. Joseph's Roman Catholic Church in Central Falls. It stands today minus its steeple, which was lost in the 1938 hurricane.

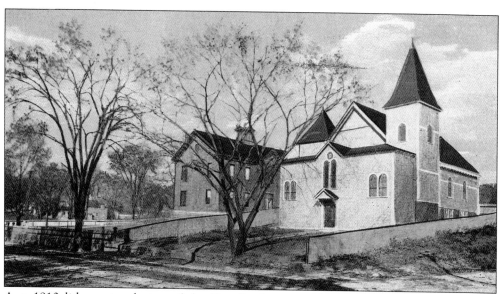

A c. 1910 litho-postcard view of the First Presbyterian Church and public school in East Lonsdale, Cumberland. The wooden church was erected in 1886 and had about sixty members of Irish and Scottish descent at the time of its founding. The first pastor at the church was the Reverend John Montgomery.

Five

Transportation

An 1825 account of the proposed canal from Worcester to Providence (the Blackstone Canal). The first attempts at opening an inland waterway were made by John Brown in 1796. Massachusetts refused consent to the plan, however, delaying it for twenty-eight years. When excavation of the canal finally began in 1824, rail transportation was relatively close at hand. (BVHS.)

An 1896 stereoscopic view of the Blackstone Canal at Lonsdale. Well-preserved areas of the canal appear much the same today as they did in the late 1800s. When the canal operations ceased in 1848, the venture was ridiculed as "General Carrington's ditch." The canal had indeed provided a cheaper means of transportation than was available overland by wagon, but it was not a reliable as had been expected. During its two decades of operation, canal barges were often blocked by ice in the winter and stuck in the mud of dry summers. In addition, the return to investors on each $100 share over a twenty-year period was only $2.75. (Mr. and Mrs. Everett Wilbur.)

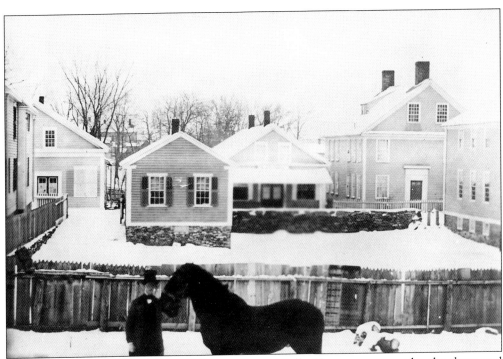

Nineteenth-century view of Central Street, Central Falls. Horses were considered a cheap and dependable means of personal transportation in the nineteenth and early twentieth centuries. This photograph of a man and his horse was taken in 1861, when Central Falls was still part of the old town of Smithfield.

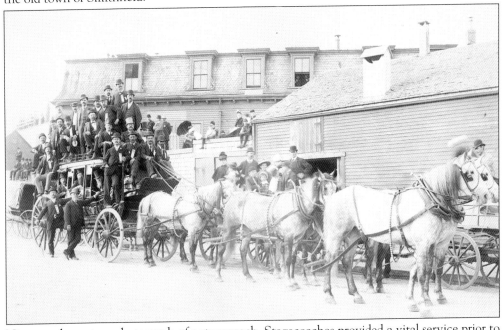

Nineteenth-century photograph of a stagecoach. Stagecoaches provided a vital service prior to the arrival of rail transportation in 1874. This particular stage made runs through Valley Falls, Central Falls (then Lincoln), and Pawtucket.

A c. 1910 photograph of the Whipple Bridge, Cumberland/Lincoln. The first bridge across the Blackstone River at this site was constructed in 1764. A total of $1273.12 was spent to build the wooden structure at that time. The funds were raised through a lottery. After numerous repairs during the eighteenth and nineteenth centuries, the State of Rhode Island replaced the unusual bridge with a more modern span in 1916.

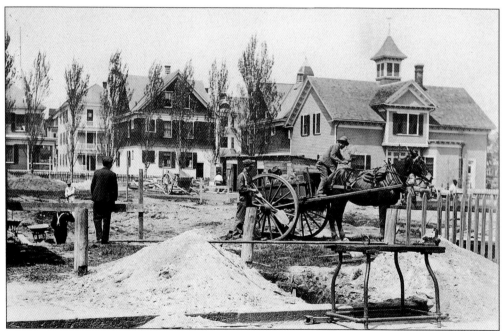

A 1909 photograph of the construction site of the Adams Memorial Library in Central Falls. Horses and wagons were used to transport building materials to the site, and to haul away debris.

Early twentieth-century photograph of Stonewall Jackson (right). Jackson became a valley trolley car operator after a decline in mill-building activity. He is shown here in uniform beside his wife, Edith (Lockwood) Jackson. (Helen Smith.)

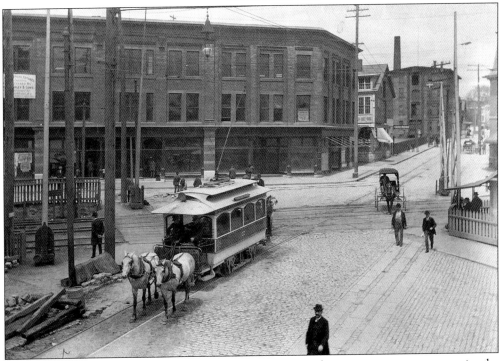

In-town transportation. By the latter part of the nineteenth century, mass transportation by horse-drawn and electric means had become available in the more thickly-settled areas of the Lower Blackstone Valley. (BVHS.)

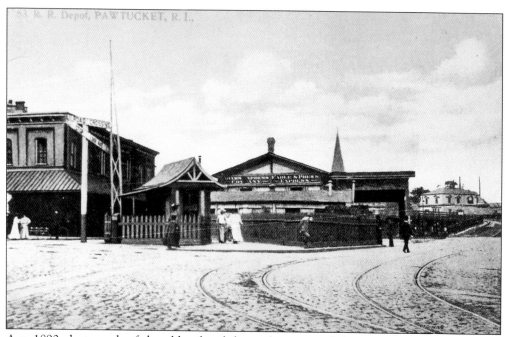

A c. 1890 photograph of the old railroad depot that serviced the mass transport and freight needs of Pawtucket. This site was later used for the construction of the Imperial Theater.

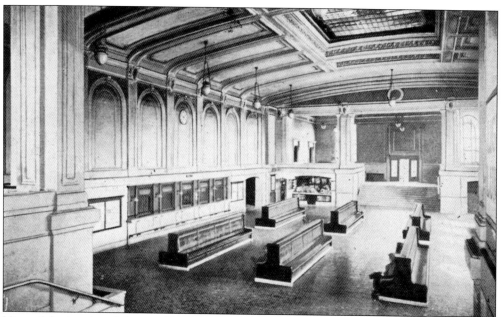

View of the interior of the new Twin City Train Station. The station was built on the city lines of both Central Falls and Pawtucket in 1913.

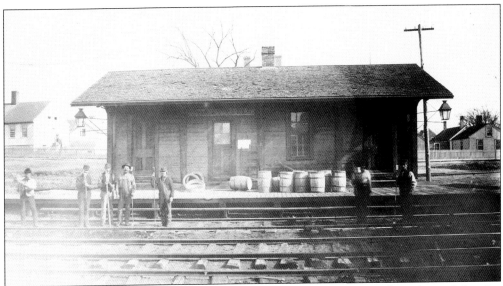
Valley Falls Train Depot, Cumberland. Railroad workers took a break and posed for this photograph in 1885. The Valley Falls Depot was the third stop from the Providence station.

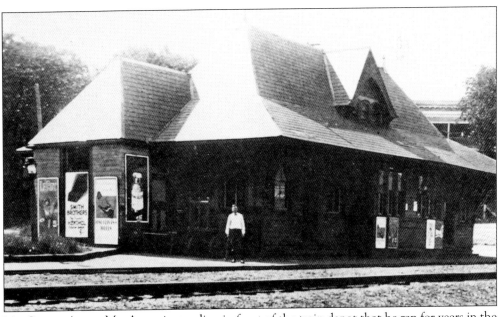
Mr. George Auger. Mr. Auger is standing in front of the train depot that he ran for years in the village of Manville.

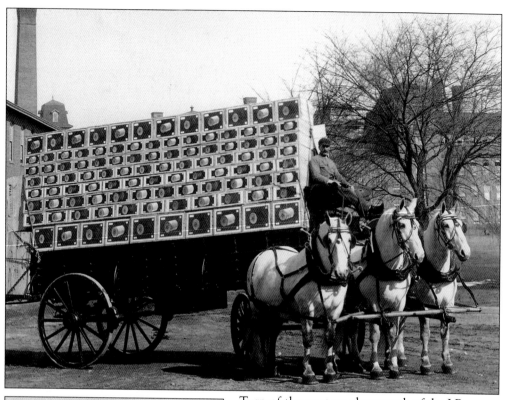

Turn-of-the-century photograph of the J.P. Coats' three-horse hitch and wagon. The manufacturer preferred to use its own company wagon to handle local wholesale deliveries. (BVHS.)

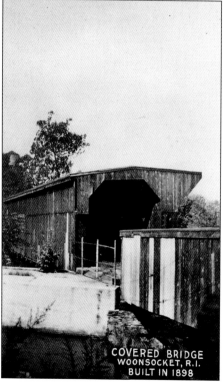

Covered railroad bridge, Woonsocket. While the valley can't boast the types of covered bridges that are found in northern New England, the New York, New Haven and Hartford locomotives passed through covered railroad bridges in Woonsocket. This particular bridge was constructed in 1898.

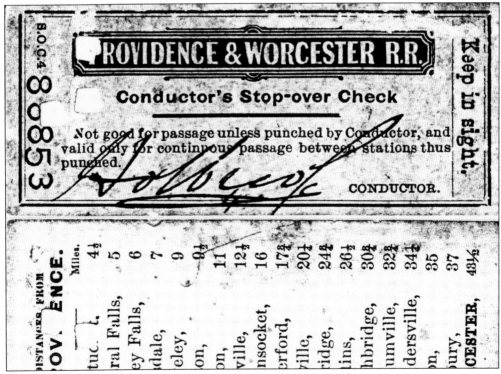

An 1876 freight check for the Providence & Worcester Railroad Company. The railroad provided a remarkably efficient freight service. Even so, it ran into some problems of its own. The intense competition from other rail lines made it more profitable for the P & W to lease its rails to other railroad companies.

Providence & Worcester Railroad ticket, c. 1880. The P & W also ran a passenger service in its early days. The reverse of this ticket lists all of the communities in the valley with depot services and their distance from the Providence station. (Gregory Barbiaz.)

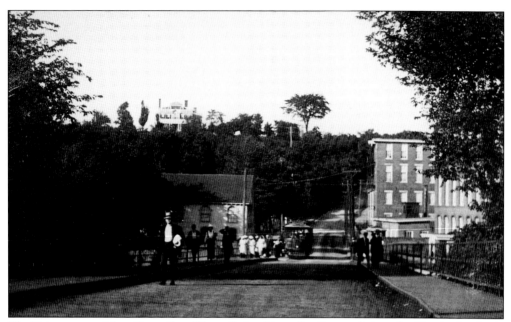

The Fairmount to Manville trolley. The rails for this trolley line ended on the Cumberland side of the river. Workers took the trolley from Woonsocket and Cumberland to the Manville Mill. It then had to reverse direction to return by its single rail to the top of the hill.

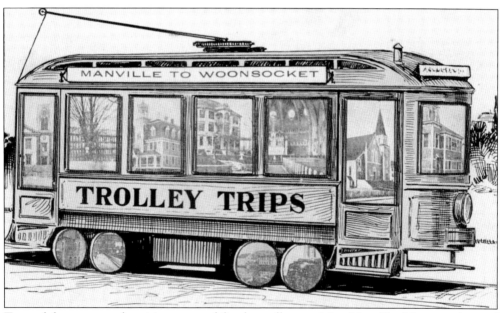

Turn-of-the-century advertising postcard for the trolley servicing Manville. Many residents of Manville took advantage of the 5¢ trolley to visit relatives and friends, and do some shopping on weekends.

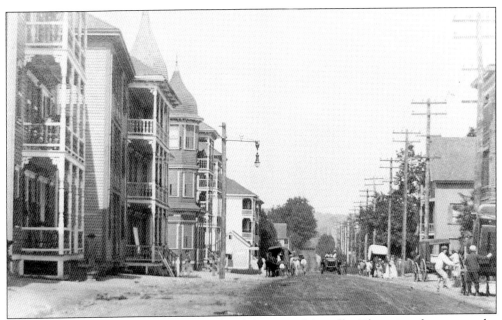

Early 1900s photograph postcard of Railroad Street in Manville. This view documents the transition from horse-drawn carriages and wagons to the automobile. All three are present in this picture. Also note the old gas lantern-type street light on the left-hand side of the street.

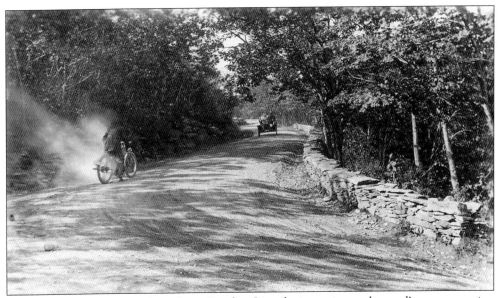

A view of early motoring along Great Road in Lincoln just prior to the road's reconstruction in 1926.

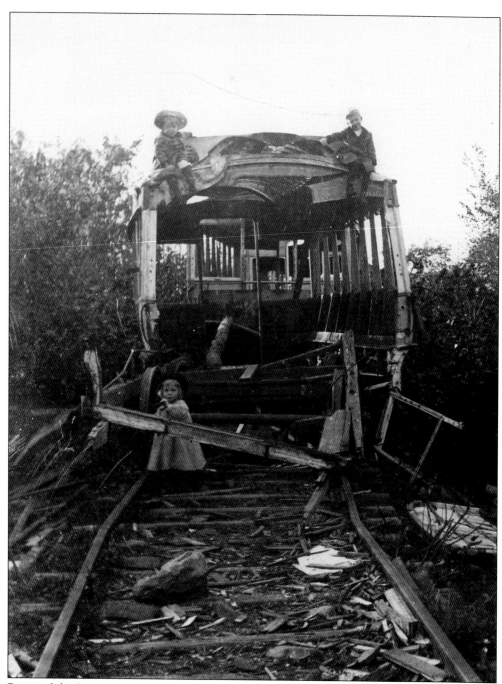

Ruins of the Iron Mine Railroad, Cumberland. Located near the Elder Ballou's meetinghouse was "Iron Mountain," a rock hill of the iron-ore bearing mineral "Cumberlandite." Constructed in 1900 for the transportation of ore to Woonsocket, the venture was not fruitful and was soon abandoned. This photograph, taken in 1910, shows the condition the rail bed and one of the cars a mere ten years later. The photograph was taken by A.L. Sherman of Cumberland and includes his children; from left to right are Leroy, Arthur, and Raymond.

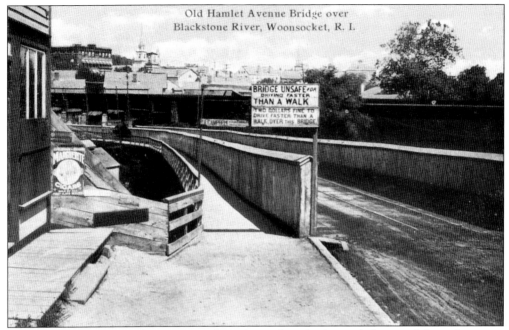

Old Hamlet Avenue Bridge, Woonsocket. A one-lane bridge and the possibility of greeting an oncoming trolley led to the erection of the warning sign. A fine of $2 was set for driving faster than a walk. Increasing numbers of motorized vehicles forced the re-design of many valley bridges in the late nineteenth and early twentieth centuries.

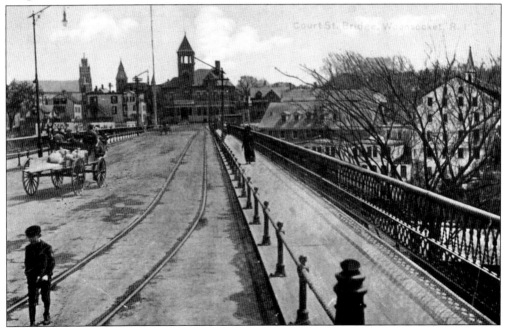

Court Street Bridge, Woonsocket. Engineered with an eye towards the future, this c. 1895 bridge was wider than earlier bridges in Woonsocket and allowed both road and trolley traffic at the same time. A valley fixture for many years, the bridge is slated for replacement. The towered building in the background is the old granite courthouse.

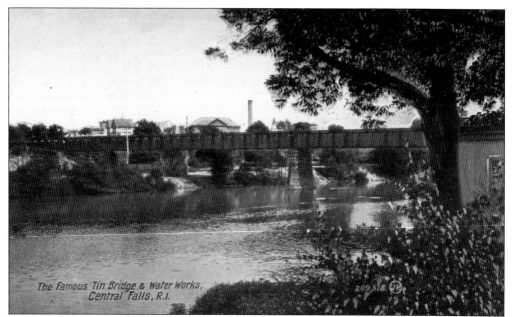

Early 1900s printed postcard of the tin bridge and water works in Central Falls. All of Central Falls' early bridges were replaced with concrete structures between 1905 and 1915.

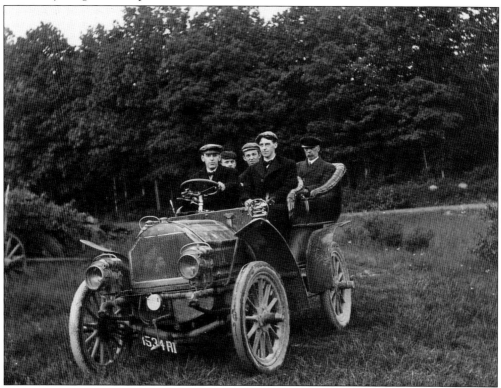

Driving excursion, Cumberland Hill. The novelty of motoring is explored by these men who were photographed by A.L. Sherman driving around the area of Cumberland Hill on a Saturday afternoon in 1908. (BVHS.)

Six

Education

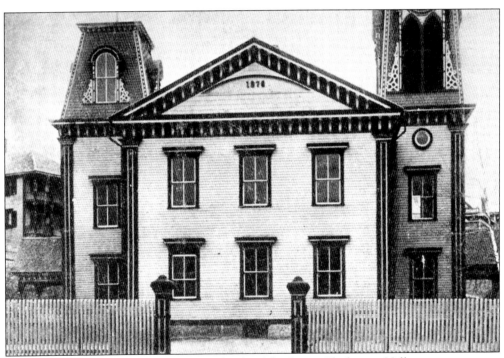

First Manville public school. The early schools of the Lower Blackstone Valley were one-room schoolhouses where children of all ages were grouped together, but instructed at different levels. Growing enrollments in the crowded mill villages made this system impractical. Often the mill companies themselves provided land and constructed the first multiple-room village schools. In addition, they often built the first libraries for the school children and community at large. Pictured above is the first Manville public school, built by mill owner Samuel Man in 1876. It was a magnificent building with an unusual bell/clock tower. School was held on the first floor only, the second being reserved for community dances. Samuel Man loved to dance. (Photograph c. 1900, Roger Gladu.)

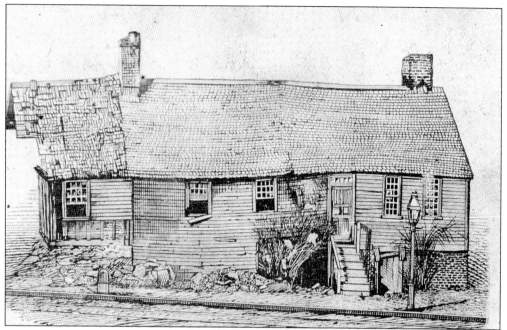
Old Jones Schoolhouse (c. 1750), Pawtucket. This early schoolhouse was located on Main Street and was also known as the Eleazer Jenks House. In 1830, the well-known Sam Patch, "the bridge jumper," lived here with his mother.

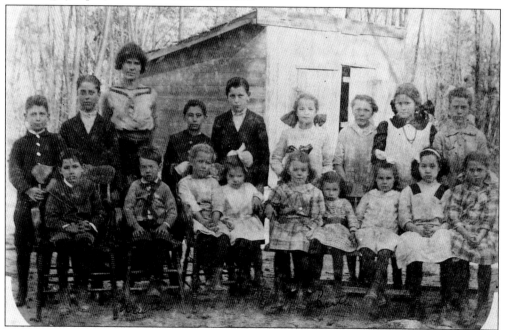
A 1916 class photograph, Pullen's Corner School, Lincoln. Located on Angell Road, eight different grade levels were taught at this school for the children of local farmers. Estelle Collier, the teacher, baked potatoes for the children's lunch using a kerosene stove, hence the nickname "Baked Potato School." Children of the Cunningham, Myers, Perrygold, Sonner, and Tucker families are shown here. (BVHS.)

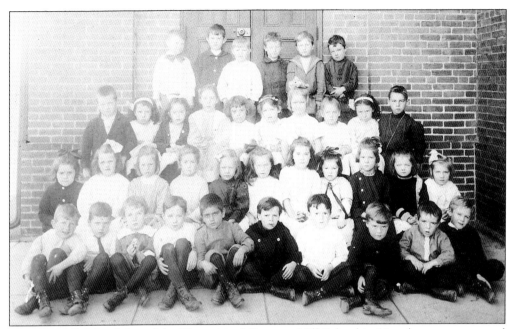

Prospect Hill School, Lonsdale. The original Prospect Hill School in Lincoln was constructed on Front Street by the Lonsdale Company and was built to educate the children of its operatives. The original school burned, but the town of Lincoln constructed a new brick school at the site. Pictured here in front of the school is grade one in 1913. (BVHS.)

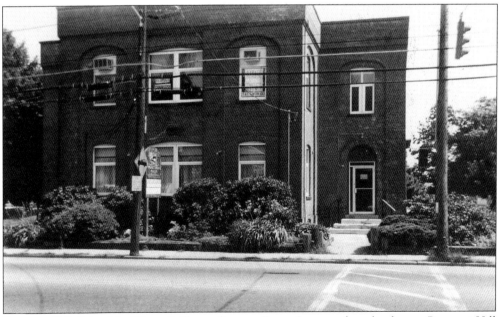

Prospect Hill School building. Still standing on Front Street today, the former Prospect Hill School building now houses the dental office of Dr. John Begg, DDS.

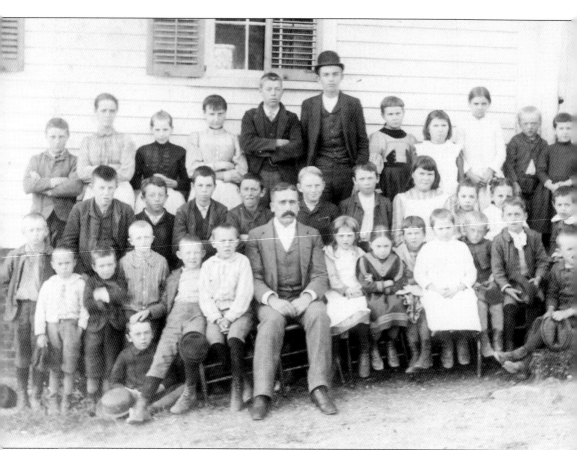

Late 1800s photograph of the old Limerock School on Wilbur Road, Lincoln. The children of Limerock were educated at this Wilbur Road site for many years. Considered a sizable school for its day, there were separate entrances and coat rooms provided for girls and boys. Fresh water for the school was fetched daily from David Wilbur's well, and the children ate their lunches beneath a huge oak tree in front of the building. Pictured fourth from the right in the back row is Carrie E. Northup; in the same position of the middle row is her sister, Elizabeth E. Northup. The teacher is Ernest Wilbur. The old school is now a private home. (BVHS.)

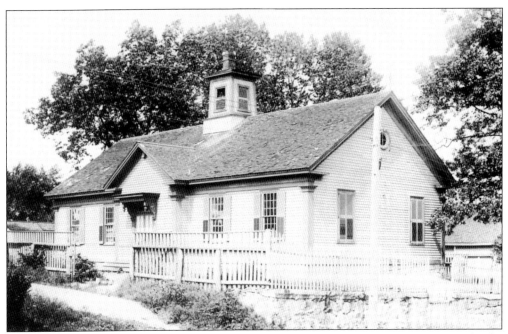

Albion's "primary school," built in 1842. The first teacher at this two-room school was Phoebe Mann. After the new brick school was built, it was turned into a parochial school for St. Amrose Parish. Prior to that, Albion residents who wanted a parochial education for their children had to send them by rail to Manville. (Gordon Jackson.)

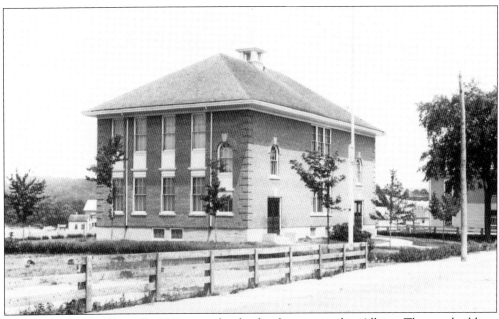

New brick school, Albion. In 1907 a new brick school was erected in Albion. The new building, with its spacious classrooms, was a vast improvement over the cramped quarters of the two-room primary school. (Gordon Jackson.)

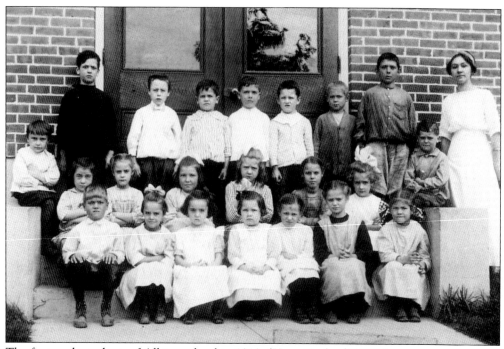
The first grade students of Albion school in 1912. (Hope Tucker/BVHS.)

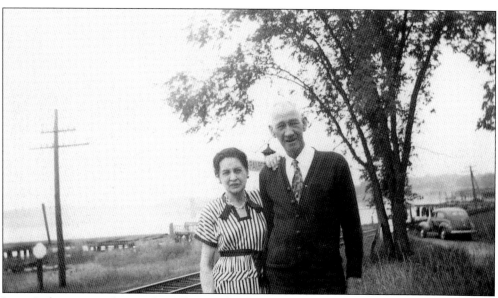
Leita Jackson, a teacher at the Albion School. Mrs. Jackson and her husband John Jackson posed for this photograph in the late 1930s.

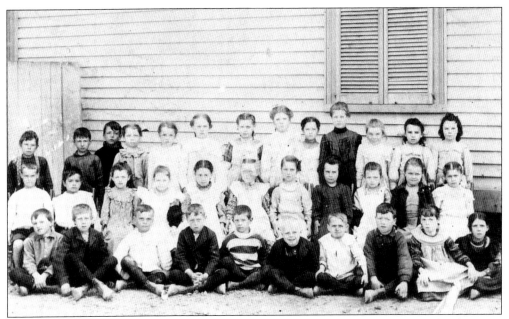

A turn-of-the-century photograph of a class at the original Manville Public School. Aaron Mann, a descendant of Samuel Man (Samuel used only one N in his name), is shown in the first row, third from the left. (Roger Gladu.)

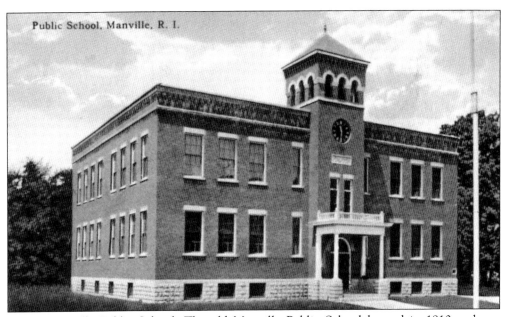

"New" Manville Public School. The old Manville Public School burned in 1910 and was replaced shortly thereafter with this new brick version. Used by the Town of Lincoln well into the 1960s, the building has since been converted into an apartment complex.

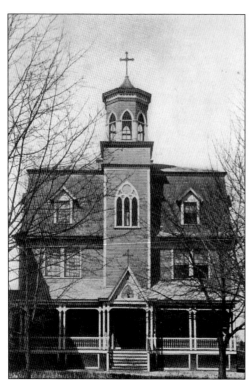

The old St. James School/Ecole St. Jacques on Division Street in Manville, as it appeared in 1910. Constructed in 1876, this school provided parochial education to the village's French-Canadian Roman Catholic children. It was a bilingual school session, with one half of the day taught in French, the second half in English.

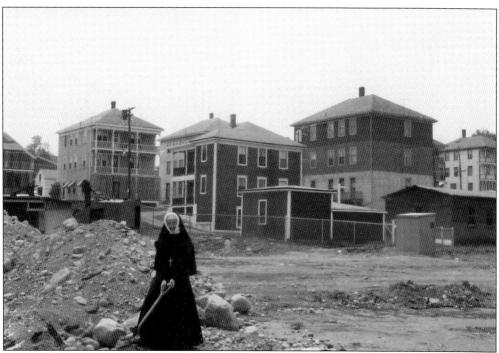

Sisters of St. Anne. In 1959, St. James Parish set the cornerstone for a new St. James School. Here a member of the Order of Sisters of St. Anne grabs a shovel to help out with the groundbreaking. (Dr. George Kokolski.)

A very young Mattie (Jenckes) Potter. Mrs. Potter would grow up to become a well-known educator at the Saylesville school in the first half of the twentieth century. (Hope Tucker, BVHS.)

Mrs. Mattie Potter (first row center), with her eighth-grade class at the Saylesville school in 1928. She taught literally hundreds of students during her tenure as a teacher in the town of Lincoln's school system. (Hope Tucker, BVHS.)

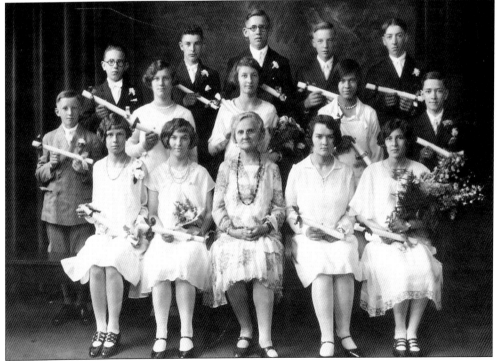

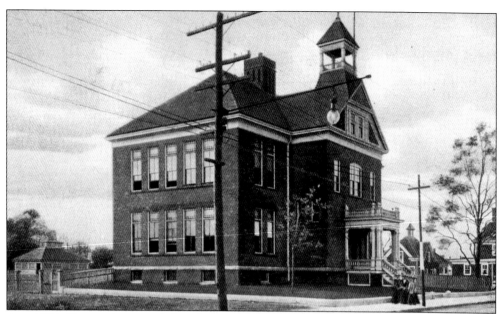

A c. 1914 illustrated postcard that shows the building and grounds of the Valley Falls High School in Cumberland. In later years, additions were made to this school and it eventually was renamed after B.F. Norton, a well-known Cumberland educator. The building no longer stands.

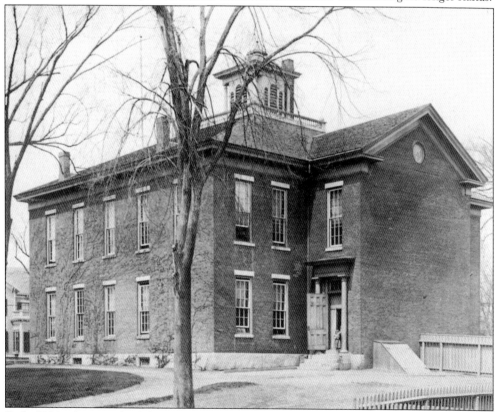

Early 1900s photograph of the Broad Street school in Pawtucket, as seen from Jenks Street.

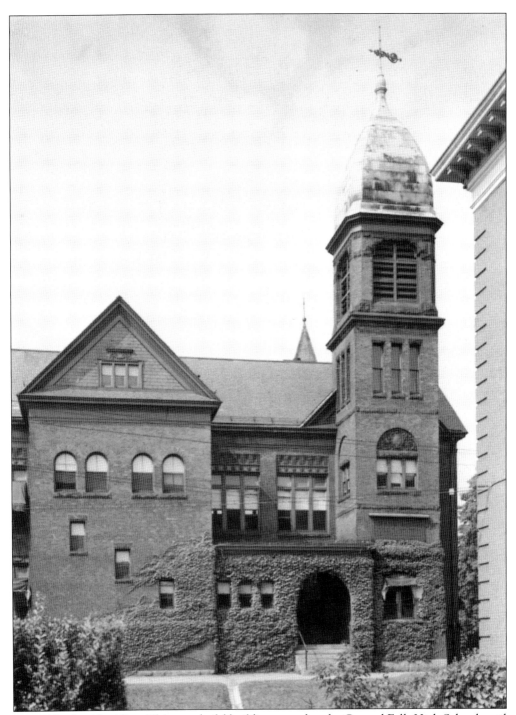

An 1889 school building. This wonderful building served as the Central Falls High School until 1928, when it became the city hall. The city clerk's office, which is located in the building, contains many of the older records of Smithfield/Lincoln up to 1895. A vote taken among Lincoln's fire districts that year set Central Falls apart from the town of Lincoln. Central Falls became a city in its own right the very same year.

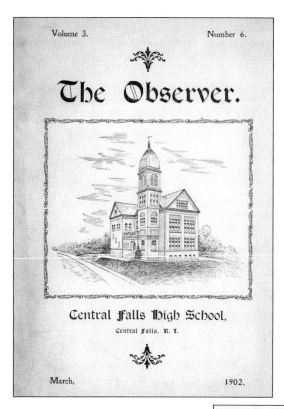

A 1902 cover of *The Observer*, Central Falls High School's magazine. This monthly publication carried a variety of articles of interest to the student body, faculty, and parents.

A 1901 copy of the program for the graduating exercises for Central Falls High School. For a number of years these ceremonies were held at the new Congregational church on High Street.

Seven
Disasters

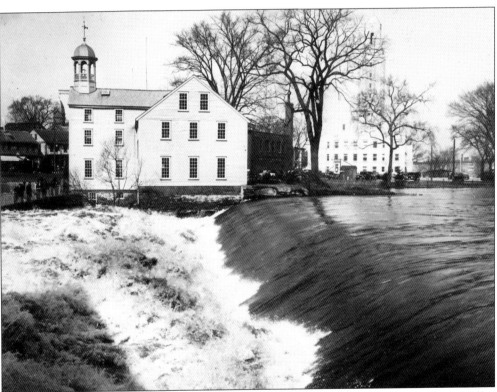

Photograph of the rising Blackstone River. Over the years, the Lower Blackstone River Valley has seen its share of tragedy and misfortune. The beautiful river which snakes harmlessly through our communities most of the time is also capable of unleashing terrible devastation. Fortunately these occurrences are infrequent and usually related to a specific weather event. Nonetheless, to see the Blackstone River at its worst during one of these episodes is a humbling experience. In this 1936 photograph, Pawtucket residents nervously watch the rising waters of the Blackstone after the heavy March rains of that year. (BVHS.)

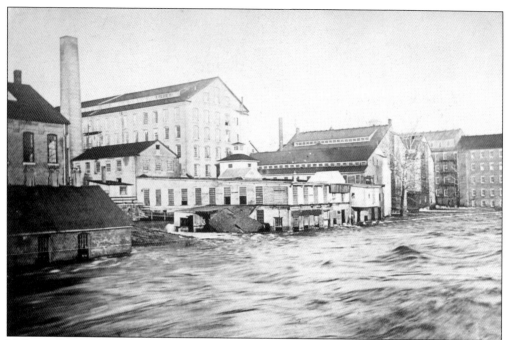

Valley Falls, Cumberland. In February of 1886, a wet winter and quick thaw produced a flood. Many residents at that time believed they had experienced the worst the river could offer in the way of flooding. Their children, however, would learn in later years that this was only one flood of the many which would eventually visit the valley.

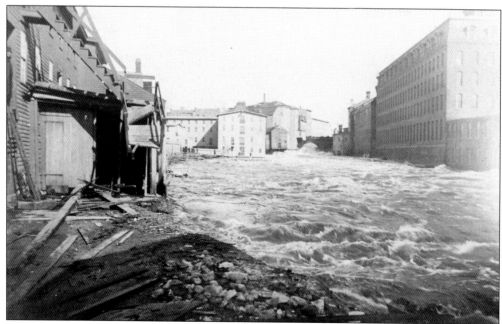

Another view of the February 1886 flooding in Valley Falls. The flood damage was apparent after the waters began to recede. Although damaging, spring floods prove to be less of a threat to the communities of the valley than those associated with the worst hurricanes.

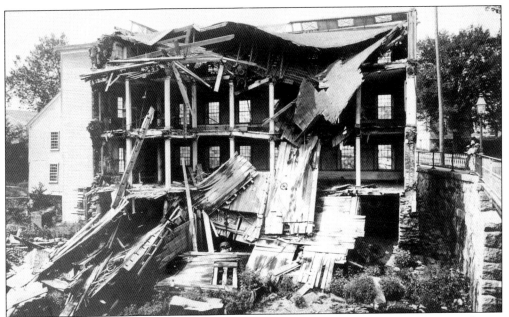
Photograph of Abbot Run Cotton Mill in Valley Falls, Cumberland. This photograph was taken as the building lay in ruins, awaiting demolition in the summer of 1886. Manufacturing equipment is visible in the rubble. (BVHS.)

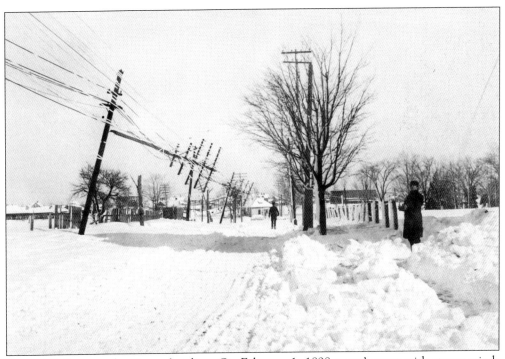
Central Falls, near the Pawtucket line. On February 1, 1898 a nor' easter with strong winds struck the valley, knocking out power in those areas lucky enough to have electrical service. The telephone poles overloaded with multiple cross-ties seemed the most vulnerable.

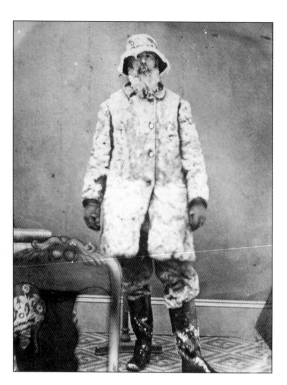

Samuel Collyer, chief of the Pawtucket Fire Department. Chief Collyer posed for an unusual photograph after the nineteenth-century flour mill fire.

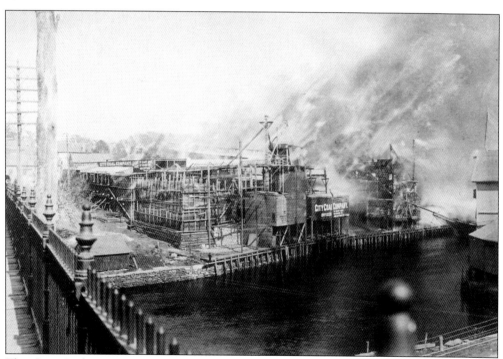

The City Coal Company, Pawtucket. In 1894 the operations of the company went up in flames. It was all firefighters could do to keep the flames from spreading beyond the property. Fortunately, one side of the business faced the Blackstone River. (BVHS.)

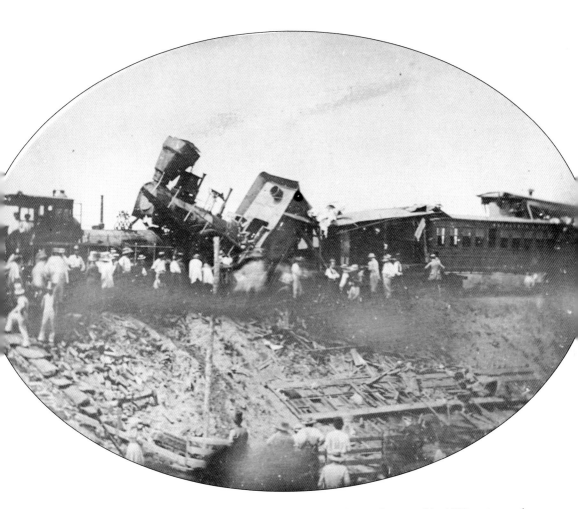

Train wreck near Cumberland/Central Falls, (Smithfield), line. This terrible 1853 train crash occurred on the Worcester track about 1/4 mile above the Boston switch. It was the result of numerous problems associated with railroad transportation when the industry was in its infancy. Timing was critical when trains were sharing a common stretch of track. In this case, the train going north was the regular Worcester commuter run. The one heading south was an excursion train, running late and traveling as fast as it could down-grade. The Worcester train was able to come almost to a full stop before the excursion train plowed into it. At least seventeen people lost their lives in this calamity.

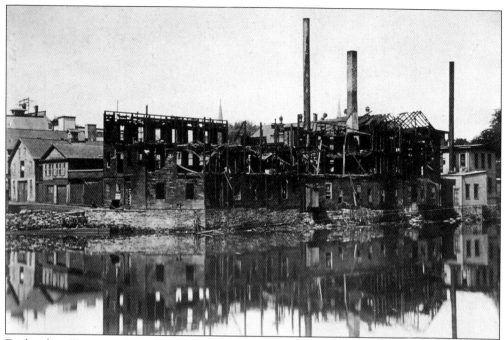
Fairbrothers Tannery after a devastating fire at the turn of the century. This tannery was located on Slater Avenue in Pawtucket. (BVHS.)

Little three-year-old Lauretta Savauge. Loretta's was one of the first fire-related deaths in the village of Manville. She died tragically on February 26, 1915, when her clothes were ignited by an oil lamp which had been tipped over accidentally. (Roger Gladu.)

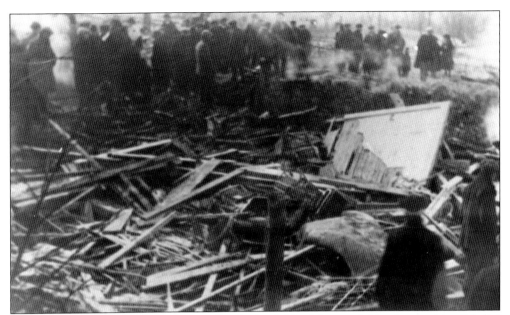

Pleasant View Avenue gas explosion, Cumberland. Neighbors and friends stared in disbelief at the devastation wrought by a natural gas explosion on January 28, 1924. Fifteen people, including an entire family, lost their lives in this freak event. (Dr. George Kokolski.)

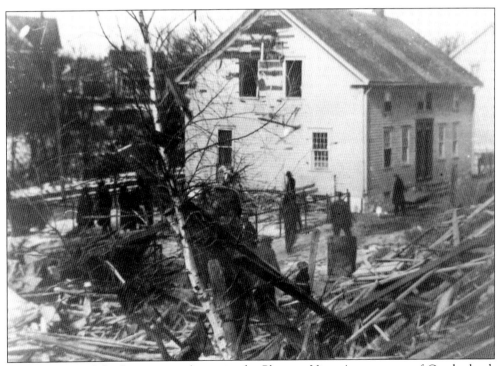

Another view of the 5 am gas explosion in the Pleasant View Avenue area of Cumberland. This view shows how the force of the blast blew out the windows and sidings of an adjacent mill house. (Dr. George Kokolski.)

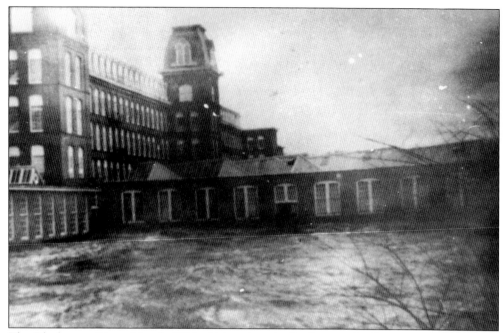

The Blackstone River, March 1936. Although a docile fixture of valley topography at most times, the Blackstone River does on occasion become an uncontrollable Goliath. Depicted in this photograph are the rising waters of the river smashing against the center span of the Manville Mill. The center span survived this flood, but would be tested again in later years. (Dr. George Kokolski.)

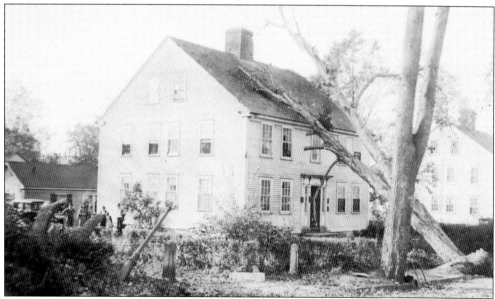

Main Street, Manville. The Lower Blackstone Valley was not the only area that suffered through the unnamed hurricane of 1938. Estimated to have been what we would now consider a category-five hurricane, it deforested our area and left scars on the landscape that took many years to heal. Shown here is a house on Main Street in Manville, one of many that suffered tree damage. (Dr. George Kokolski.)

Railroad Street and the railroad bed at Manville, August 19, 1955. Another flood, this one associated with the heavy rains of Hurricane Diane, made the Providence & Worcester Railroad bed resemble the old Blackstone Canal. Between 7 and 10 inches of rain fell from this storm. In addition to the rain and 115-mile-per-hour wind gusts, residents of the valley were also subjected to the macabre scene of coffins floating down the river from the flood-ravaged Precious Blood Cemetery in Woonsocket. Over fifty coffins were disinterred by the waters of the Blackstone River and then carried downstream. (Dr. George Kokolski.)

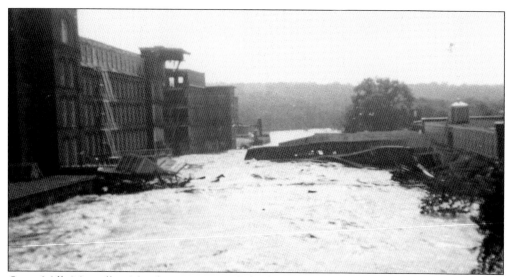

Great Mill, Manville. After having survived the hurricane of 1938, Hurricane Carol in 1954, and numerous other floods over the years, the Great Mill in Manville finally met its match in the deluge of Hurricane Diane in August of 1955. The mill's center span over the river collapsed and was washed away. (Dr. George Kokolski.)

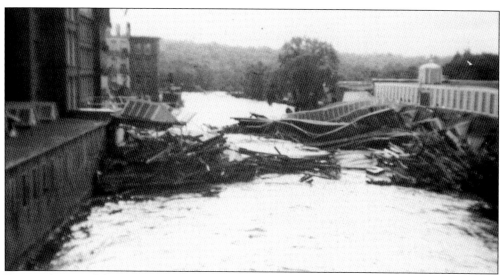

Damaged areas of the Manville Mill. After the flood waters receded, the damaged areas of the Manville Mill lay exposed in the riverbed. In addition to the visible damage, the mill's sprinkler systems were knocked out. This left the mill defenseless against a fire which would break out later that year. (Dr. George Kokolski.)

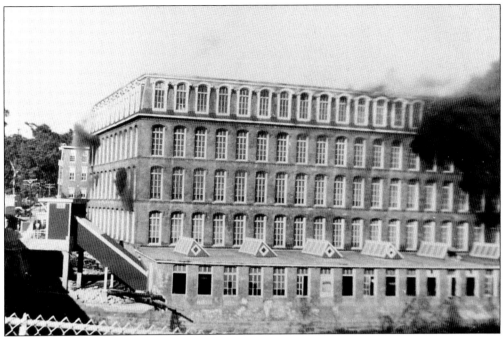

Manville Mill fire, 1955. The first wisps of smoke spelled doom for the 143-year-old Manville Mill. The alarm sounded at 4:20 pm on September 12, 1955. Within ten minutes, the middle portion of the mill was completely engulfed by flames. Still the largest fire on record in the state of Rhode Island, twenty-nine fire departments responded with equipment. (Roger Gladu.)

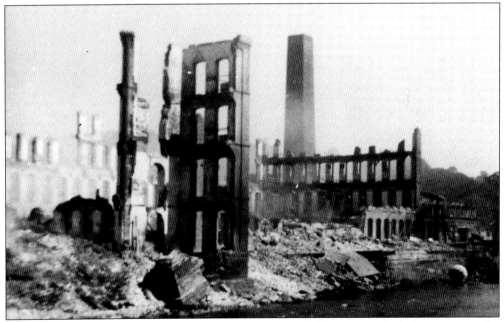

Ruins of the Manville Mill. The smoldering ruins were all that remained of what was once the largest cotton mill under one roof in the country. Investigations concluded that work being done on flood-damaged areas resulted in the ignition of a refuse pile, possibly by a workman's torch. (Roger Gladu.)

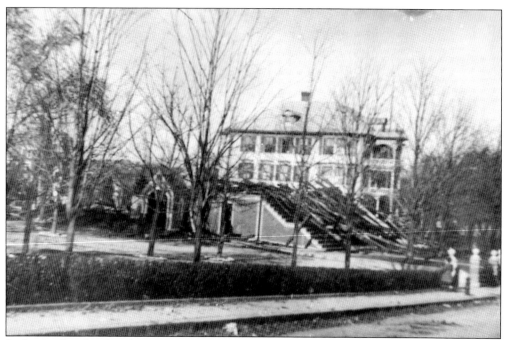

St. James church, after the 1919 fire. A devastating fire destroyed the original wooden St. James church on November 10, 1919. This photograph depicts the aftermath of the fire, and is the only view now known to exist. (Dr. George Kokolski.)

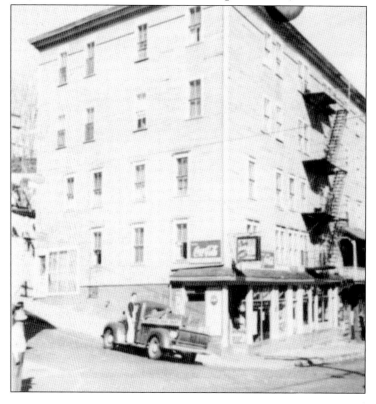

The Bijou Theater, Winter Street, Manville. After the fire, Roman Catholic services for St. James parish were held in a number of locations including the Opera House and the Bijou.

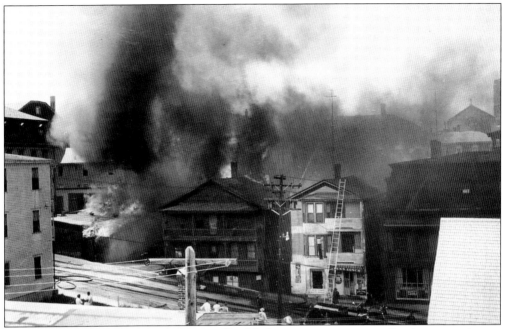

Summer and Winter Street fire, Manville. Nothing is more potentially disastrous than a fire raging in the middle of a mill village full of closely built, triple-decker housing. Luckily, firefighters were able to control this fire, which destroyed several apartment houses on June 30, 1956. (Roger Gladu.)

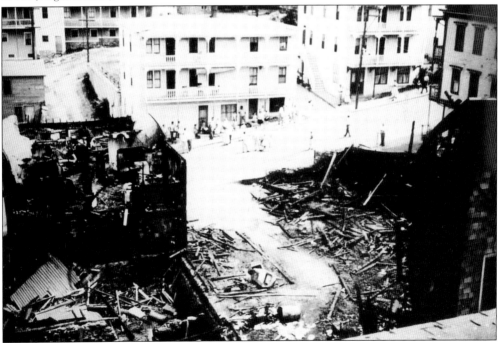

The aftermath of the Summer and Winter Street fire. The fire consumed several buildings before being extinguished. Ironically this very same block had burned to the ground earlier in the century.

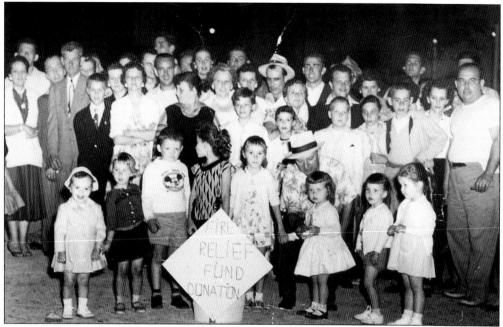

Manville Ranger's Club, Bouvier Avenue, Lincoln. In 1956, a fire relief fund benefit was held at the club. The villagers held the benefit to raise money for neighbors who lost their homes and belongings in the fire which destroyed the Summer/Winter Street block earlier in the year. Neighbor helping neighbor is a valley tradition. (Roger Gladu.)

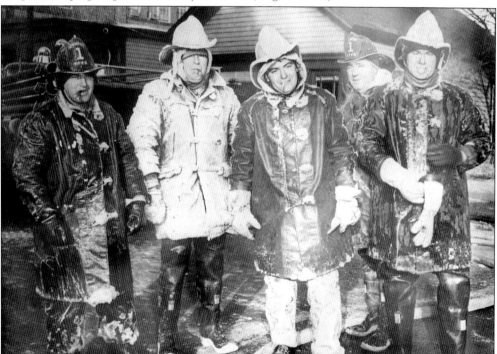

Valley Falls, Cumberland. Chief John K. "Dusty" Burns (second from the left) and his men posed for a photograph after a 1960s fire at "The Fair" in Cumberland. (Marie Gorman.)

Eight
Community

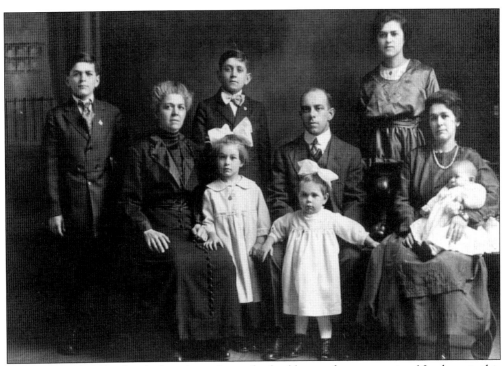

A valley family. The family has always been the backbone of a community. Nowhere is this truer than the Blackstone Valley. Local communities were made up of large families with strong ties to their neighbors. Many people who lived in mill villages were related, or at the very least knew each other well. The villages themselves were a form of extended family. Pictured above is one such mill village family of French-Canadian descent who chose to call the Lower Blackstone River Valley their home. They are, from left to right: (front row) Anna Belhumeur, Rita Belhumeur, and Marie-Rose Belhumeur; (middle row) Alexina Chenail, Norbert Belhumeur, and Marie-Louise Belhumeur; (back row) Hector Chenail, Eugene Chenail, and Clerinda Chenail.

Samuel Pearson, owner and operator of the very successful Pearson's Market on Lonsdale Avenue in the valley. People depended on Sam for fresh groceries.

Clarence Pearson. Clarence was Samuel Pearson's son and was to be involved in the family business.

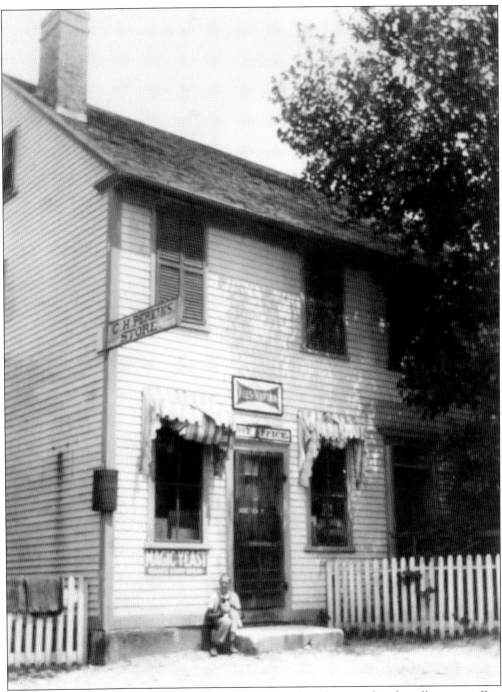

Perkin's Store and Post Office, Limerock. This local market also served as the village post office for many years. Nickel scoops and scales weighed out commodities such as coffee, tea, and sugar. Supplies were brought to Limerock by horse-drawn covered wagon. On one occasion, kegs of molasses fell out of the wagon while it was on an incline on Great Road. For a long period of time villagers could smell the scent of molasses on sultry days, and the incline was named "Molasses Hill." (Esther Wilbur.)

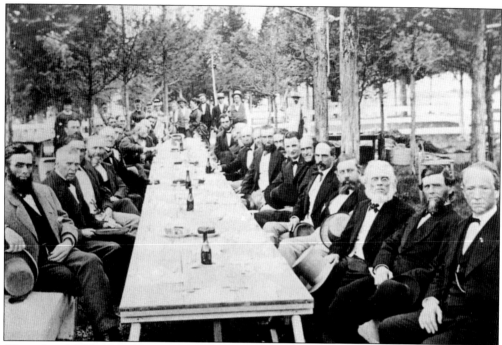

Olney Arnold. Mr. Arnold was prosperous and loved to get friends and acquaintances together. He spared no expense to transport them from the Blackstone Valley down to his nineteenth-century clambakes at Annawmscott, Barrington.

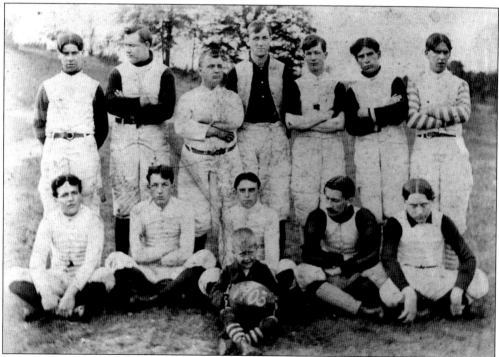

The 1903 Manville football team. By the turn of the century, youth sports were becoming a commonplace source of community pride and friendly inter-village competition.

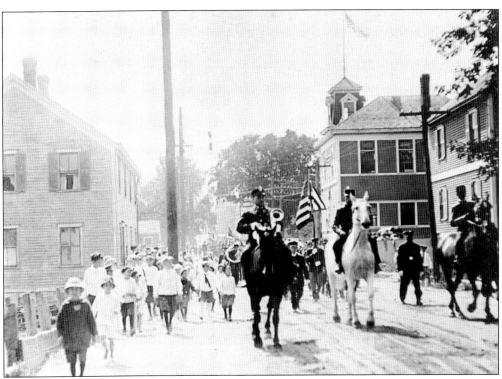

The Manville Brass Band, at the 1920 American Legion parade, Central Street, Manville. The communities of the Lower Blackstone Valley loved parades. Leading the parade on the black horse is Manville Fire Chief Seraphin Fortier. His son Henry rides alongside on the white horse. (Roger Gladu.)

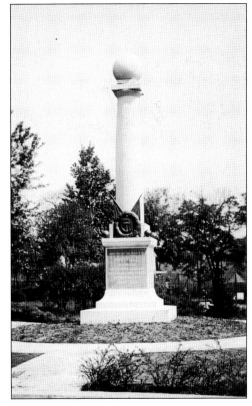

The World War I Memorial in Manville's first memorial park. This monument has the distinction of being the first one erected to veterans of the First Word War in the United States.

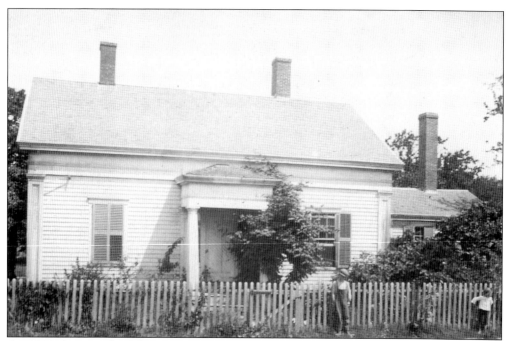

An 1896 photograph of the Curtis Home on Great Road, in the Limerock section of Lincoln. The house, barn, and store were located on a 6-acre parcel of land which extended behind the Mount Moriah Lodge building. The home is still a private residence. (Esther Wilbur.)

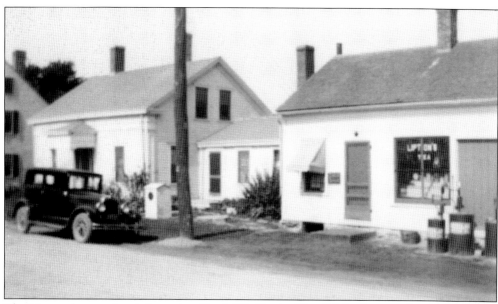

The Limerock store that belonged to Frank W. Curtis. This 1920s photograph was taken by a member of the Curtis family. The Curtis store served the needs of Limerock folk for many years. (Esther Wilbur.)

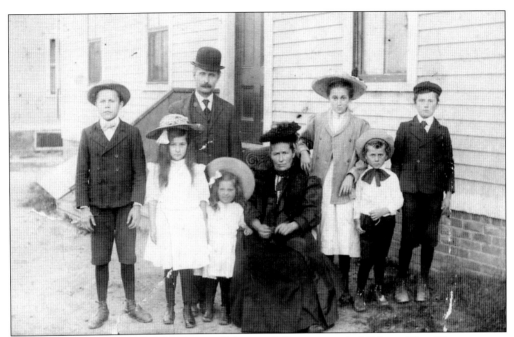

Mr. Octave Dionne, his wife Eugenie (Morneau) Dionne, and children. The Dionnes were photographed c. 1913 with their children in Albion village shortly after their arrival from Canada. Alfred Dionne (far left) and his brother Joseph "Demetrius" Dionne (far right) made the ultimate sacrifice for their adopted country in World War I. (Marie Pelletier.)

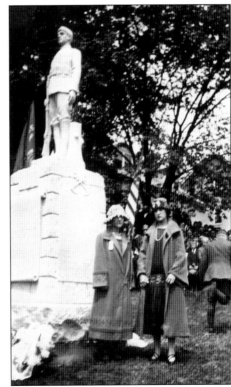

Albion World War I Monument dedication, 1925. This monument was dedicated to the Dionne brothers and other Albionites who served in World War I. The granite statue was carved in the likeness of one of the two fallen brothers. Standing to the right of the monument are the heroes' sisters, Marie-Rose (left) and Marie-Louise Dionne (right). (Marie Pelletier.)

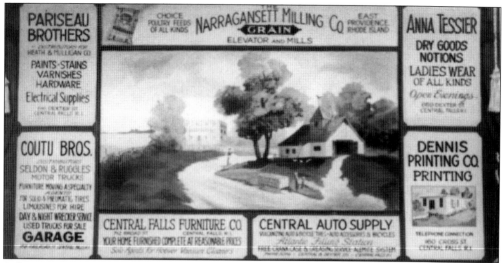

Advertising stage curtain at Northgate, Lincoln. This *c.* 1925 stage curtain, commissioned by the Grange, was hand-painted in oil on canvas by the Anderson Scenic Company. All of the advertisers were invited to the first event staged after the curtain was installed. There are few well-preserved examples of these stage curtains left in existence. (Photograph by Ken Smith.)

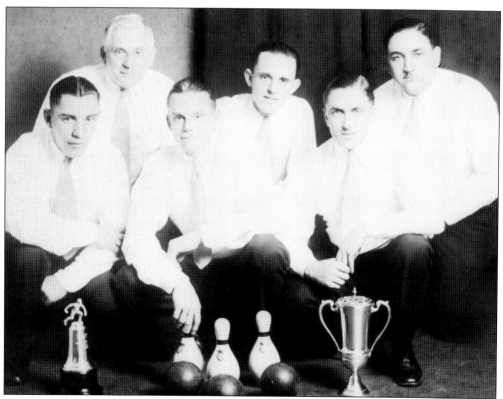

Cotton cloth room champions of the Manville Benefit Association Bowling League of 1932–33. Pictured are, from left to right: (front row) F. Romanovich, captain H. Lamoureaux, and E. Parsons; (back row) P. Lamoureaux, O. Raquier, and T. Benoint. (Carmen Benoint, BVHS.)

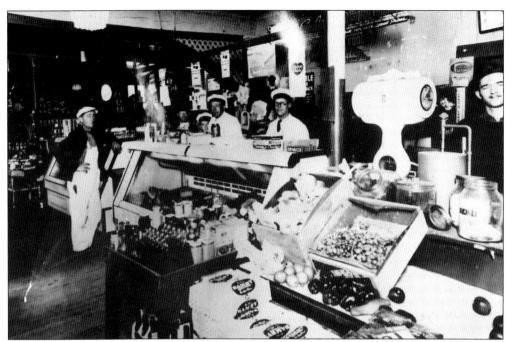

A 1930s photograph of the store known as "Gladu's Market." The Clover Farm Store on Park Street in Manville provided fresh meats and groceries along with quality service to the villagers for many years. Pictured here, from left to right, are Mr. Blais, Mr. Charbonault, Maurice Valquette, proprietor Alfred Gladu, Anthime Gauthier, and Normand Valois. (Roger Gladu.)

Maurice Durand's Barber Shop, Summer Street, Manville. Durand's was the perfect place to get a little taken off the top. In the chair getting a trim is Mr. Norbert Belhumeur. (Mr. and Mrs. Henry Beaudoin.)

Francis "Bud" Burns, a little valley cowboy of the 1930s. Francis lived in both Lincoln and Cumberland. Apparently he never lost his taste for adventure. When he grew up, he traveled Arabia as a businessman. (Marie Gorman.)

Jimmy Burns. A 1930s World Series hopeful, Burns became a merchant marine and went to sea. (Marie Gorman.)

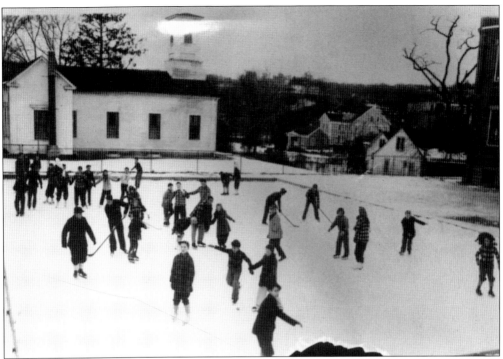

Valley children. This 1930s photograph shows valley children enjoying some skating at the rink behind the public school in Manville. The Emmanuel Episcopal Church built by Samuel Man can be seen in the background.

Romeo and Jeanette Savoie. The two are all set to go for a valley sleigh ride in the late 1920s.

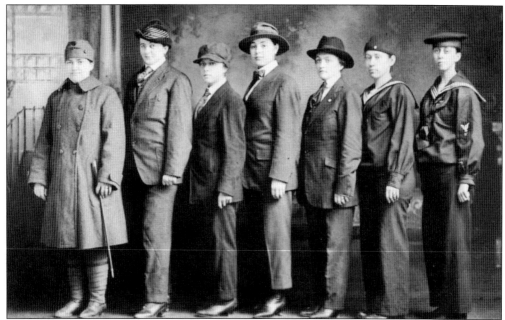

A c. 1919 photograph of Blackstone Valley girls, taken after a post-World War I patriotic show. The uniformed girl second from the right is Eva Delisle.

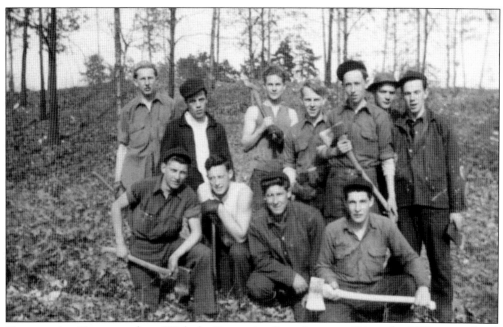

Conservation Corps members. With the Depression lingering on well into the 1930s, many local valley men joined the Conservation Corps, or CC. Here they are shown putting their talents to work in northwestern Rhode Island by clearing the forest to create George Washington Park and Campground.

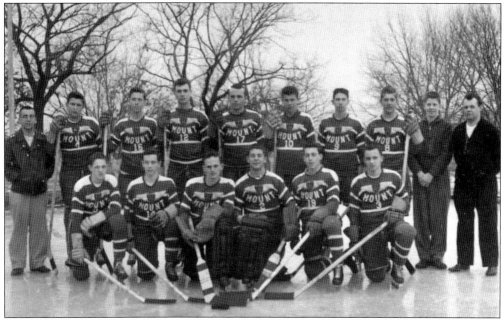

The 1956–57 Mount St. Charles Academy hockey team, Woonsocket. From left to right are: (front row) Jacques Baillargeon, Paul Lareau, Goalie Roger Gladu, goalie Bob Hamel, D. Manseau, and R. Demers; (back row) manager Cyr, Gerry Menard, Paul Breault, Marc Beabien, George Egan, G. Lavllee, T. Breault, R. Pepin, manager J. Ayotte, and Brother Laurent (coach). (Roger Gladu.)

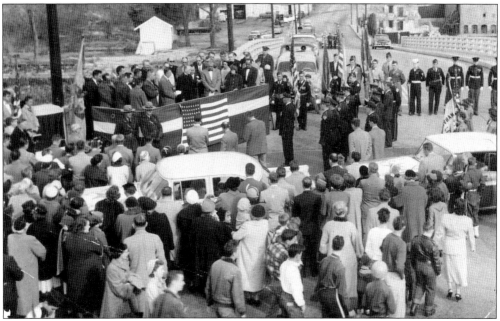

Plaque dedication, November 12, 1956. The Ukrainian organizations of the valley placed a large bronze dedication plaque on the new bridge between Manville and Cumberland. The dedication was in honor of Theodore Suptelny, G/Sgt. U.S.M.C., who was killed in action on June 19, 1944, during the World War II invasion of Saipan. (Dr. George Kokolski.)

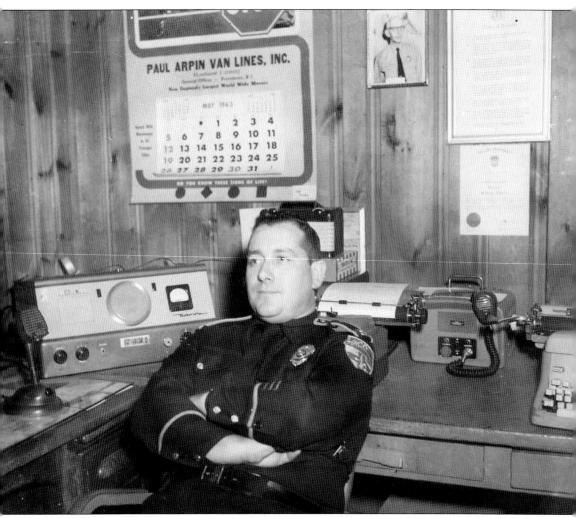

Lincoln Police Captain Lucien Gervais. Captain Gervais is shown holding down the fort at the first Lincoln police station in 1963. In August 1953 the Lincoln police moved into their new headquarters in the basement of the Lincoln Town Hall on Lonsdale Avenue. Before this town-wide consolidation of police personnel, patrolman Alderic Peloquin of Manville, Robert Reid of Lonsdale, and others performed their own village policing. Jail cells, such as the ones inside of the old music hall in Manville, were used to house local hooligans. The police station and other town offices relocated to the new and much larger Town Hall on Old River Road in 1965. (Photograph by Normand Chamberland.)

Mr. Gordon Jackson. In this 1960s photograph, Mr. Jackson, of Limerock, can be seen on a wooden scaffold helping to keep the Stephen Smith Hearthside House in tip-top shape so its history can live on into the next century.

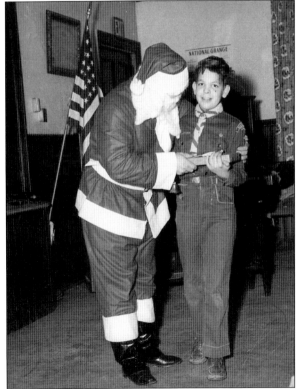

Limerock Cub Scout Lawrence A. "Larry" Smith. Larry received a gift from Father Christmas at the annual Cub Scout Christmas Party held at the Grange in 1957. Father Christmas will revisit the Grange Hall (now Northgate) in 1997 as part of the Christmas in the Valley celebration.

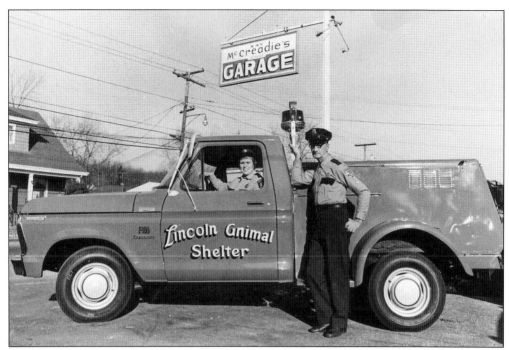

The husband-wife team of Raymond and Dorothy "Dottie" McCreadie. The McCreadies cared for the lost and unwanted animals of two communities in the Lower Blackstone River Valley. They took in strays from the town of Lincoln and the city of Central Falls at their home-based Lincoln Animal Shelter. Ray was also the youngest chief of the Fairlawn Fire Department.

Anna Belhumeur. Valley residents have always been ready to help a neighbor. Here, Anna, a Lincoln resident and employee at the Rhode Island State House, takes a blood test prior to donating during a statewide blood drive.